Zentangle
A Journey in the Round...Book 2

Jeanne Paglio, CZT

Palette Publishing

Copyright 2013 Jeanne Paglio
All rights reserved.

Copy permission: Written instructions, designs, patterns, and projects offered in this publication are intended for personal use by the reader and may be reproduced for that purpose only. Any other use will require permission from the copyright holder. Every effort has been made to ensure all information is accurate. Due to differing conditions, tools and individual skills, the publisher nor the author can be responsible for any injuries, losses, and other damages which may result in the use of this book.

Information: All images and work in this book have been produced with the knowledge and prior consent of the artists concerned. No responsibility is accepted by the publisher, printer, or author for infringement of copyright or otherwise, arising from the contents of this publication. Every effort has been made to ensure proper credit has been given.

Many thanks to Rick Roberts and Maria Thomas of Zentangle, Inc. for their instruction and permission. www.zentangle.com Zentangle® is a registered trademark of Zentangle, Inc.

Formatted by Hale Author Services

For Jenna
Who fought the battle with spirit and courage, but sadly, she lost in 2012.

At nine years old, Jenna Jacques was a bright, happy, beautiful, child who fought her cancer bravely. She took what was a debilitating form of cancer that strikes the young, and made the best of her situation. Through the Make A Wish Foundation, Jenna went to Norway to meet with and watch her favorite entertainer, Justin Bieber, perform. She was absolutely thrilled, even though she was weak from her treatments. He was truly amazed at Jenna, just as she was amazed by him.

The 'Pink Heals' Foundation did their best to make her life bearable throughout her battle. The people behind foundations such as these are incredible, brave, kind, and giving souls. We are blessed to have them in our lives. For those who have never experienced the loss of someone so young from this, or any deadly disease, you are fortunate.

This book is a mere scratch on the surface of how to eliminate stress and learn to relax and deal with the strain of what happens in our everyday lives through mindful art. There is **No** experience necessary, and never fear, there are no mistakes, only opportunities. An *OOPS* can turn into an opportunity to take your tangle to a new level you hadn't considered. Children and adults can benefit from tangling.

This, the second book in the Zentangle—A Journey in the Round series holds a variety of circular designs which include inspiration from the Celtic world and The Book of Kells. I hope you enjoy the book as much as I have enjoyed designing it for you. There are also spaces for you to work and make notes, too.

Enjoy!

Jeanne ♥

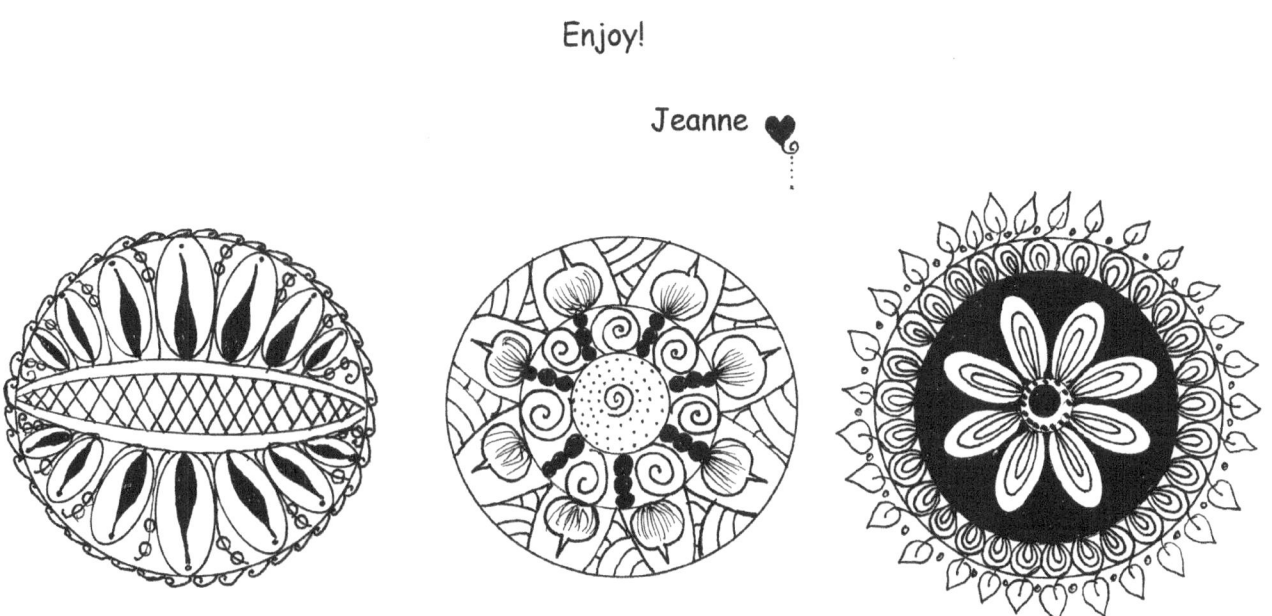

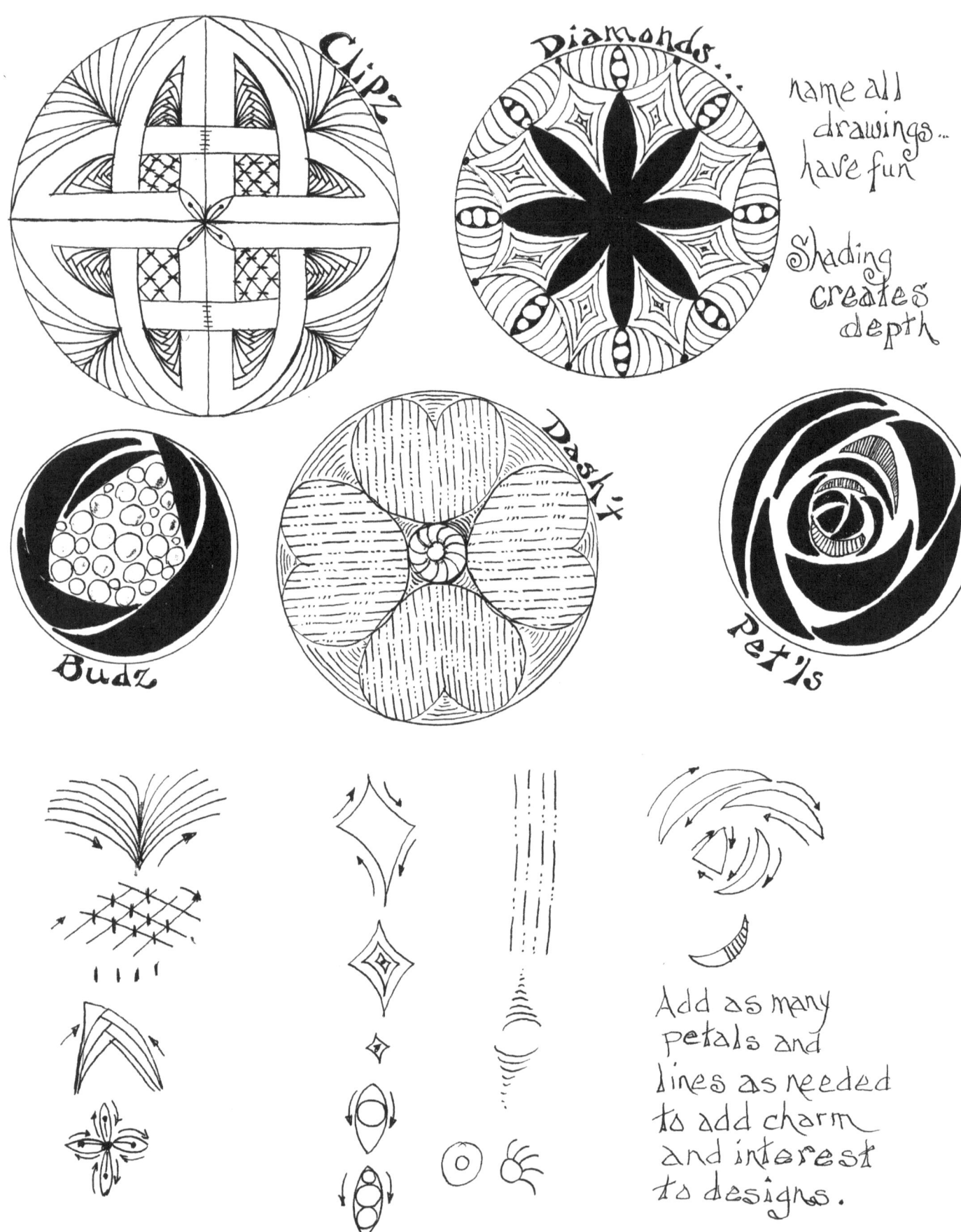

Mendalas are fascinating, their history is worth reading, and by nature they suggest everything in life comes full circle. Susanne F. Fincher has authored coloring books filled with designs ready for tangling, coloring, or admiring. As an art therapist, she guides adults in the area of personal growth through workshops on creativity. The books I have recommend and have found of interest are:

Coloring Mandalas 1—For Insight, Healing, and Self Expression

Coloring Mandalas 2—For Balance, Harmony, and Spiritual Well-Being

Go to www.Amazon.com to see Susan F. Fincher's coloring Mandala books.

Dover Publications also has wonderful books of designs that can assist in the journey to finding peace and creating harmony in the everyday struggles life can present. Dover has Mandala kits for children (or adults), and many Mandala booklets that can serve as inspiration for creating them.

Go to www.Doverpublishing.com to search for Mandala books

My next book, *Tangled... Starts & Sparks,* is also a Mandala style workbook which breaks down each design into steps to encourage and benefit those who are new to the tangling idea. Tangling is a mindful art form similar to doodling, but more intense and purposeful in the marks made. There are some square tiles, too, for those who prefer working in square or rectangular shapes.
Release for *Tangled... Starts & Sparks* is scheduled for December 2012

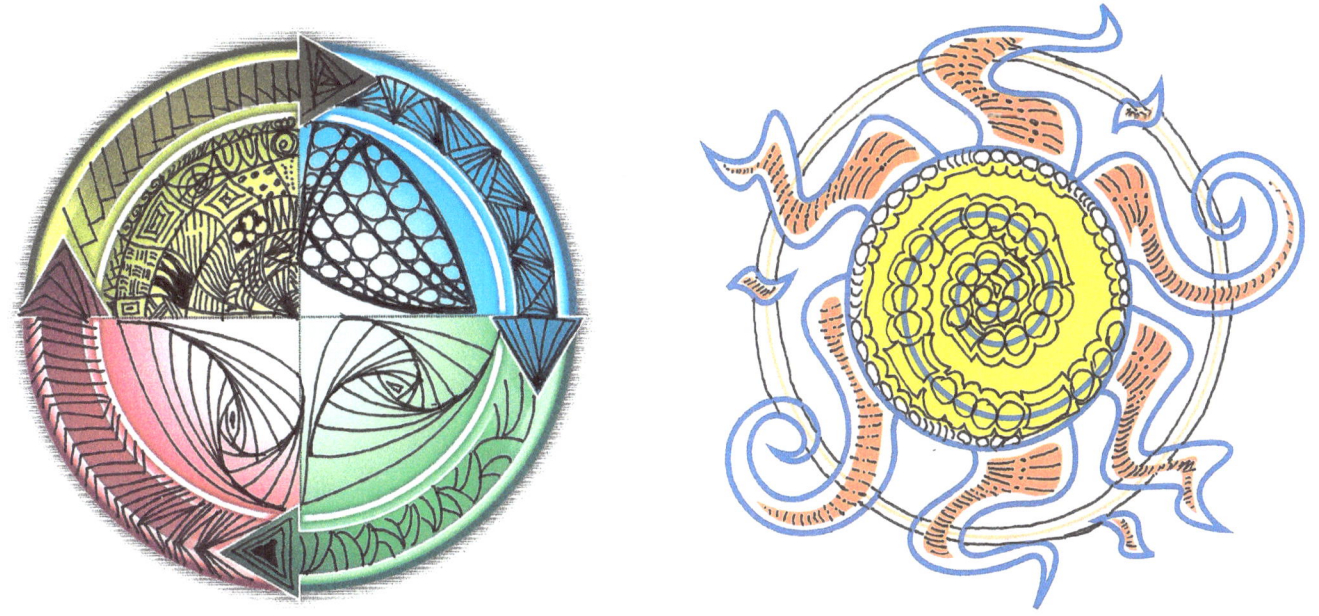

The Zentangle® art form and method was created by Rick Roberts and Maria Thomas and is copyrighted. Zentangle® is a registered trademark of Zentangle, Inc.
The designs herein are inspired by, or are in part from, the Zentangle® art form.

Instructional marks from the previous page designs.

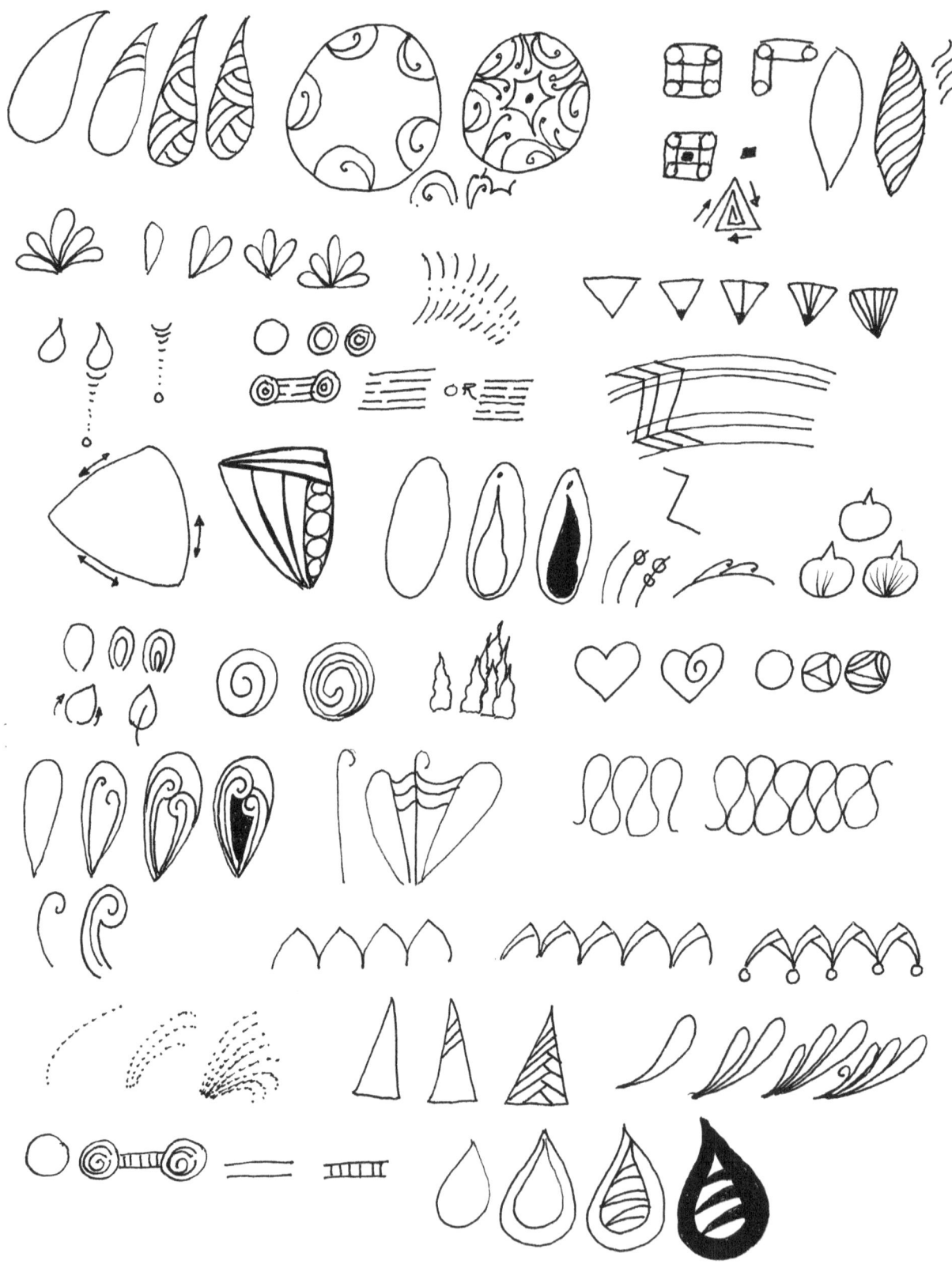

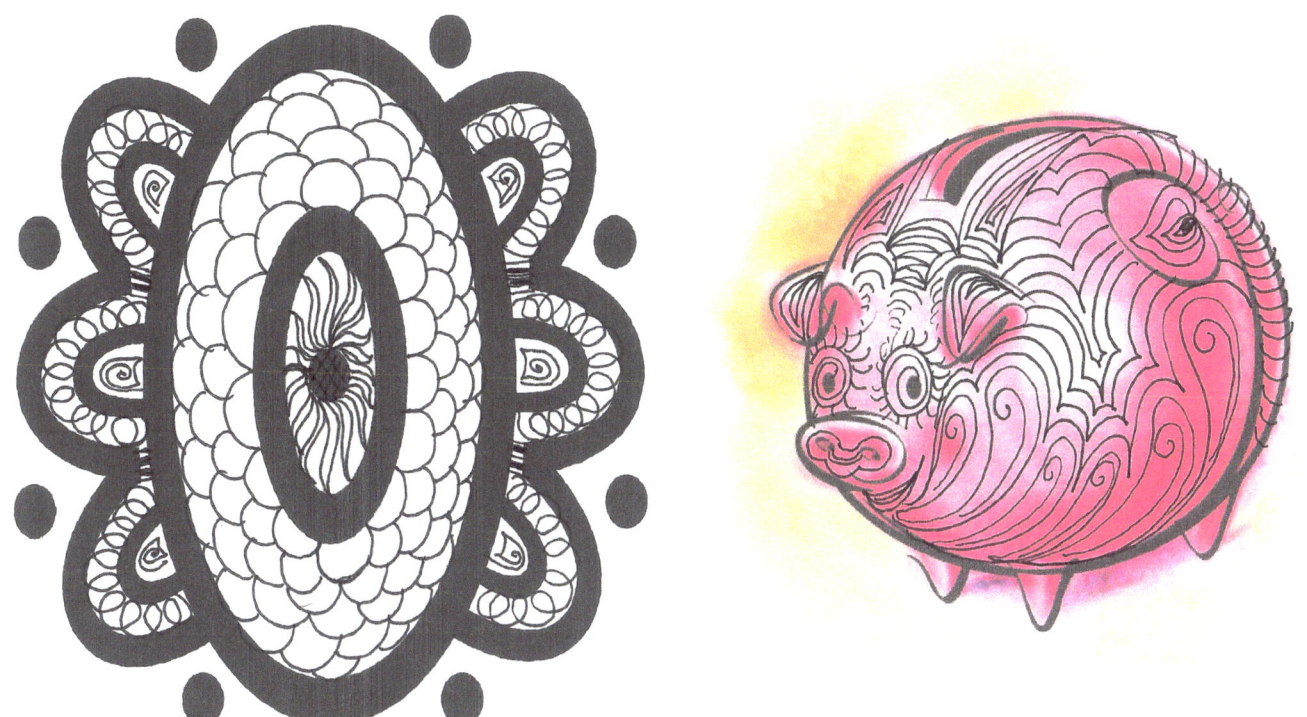

While Mandalas are round, ovals have a circular shape as well. This piggy is round, an egg is rounded, many baskets are rounded, what else is or can be round? _____, _____, _____, _____, _____,

Above are samples of how to construct the design in each of the first circles. Use as much of the design or as little of the samples to complete one of your own. Enjoy! ♥

Repetitive marks can increase balance, well-being, and relaxation. Self-expression through art can produce a calming effect, bringing with it an greater sense of worth and well-being.

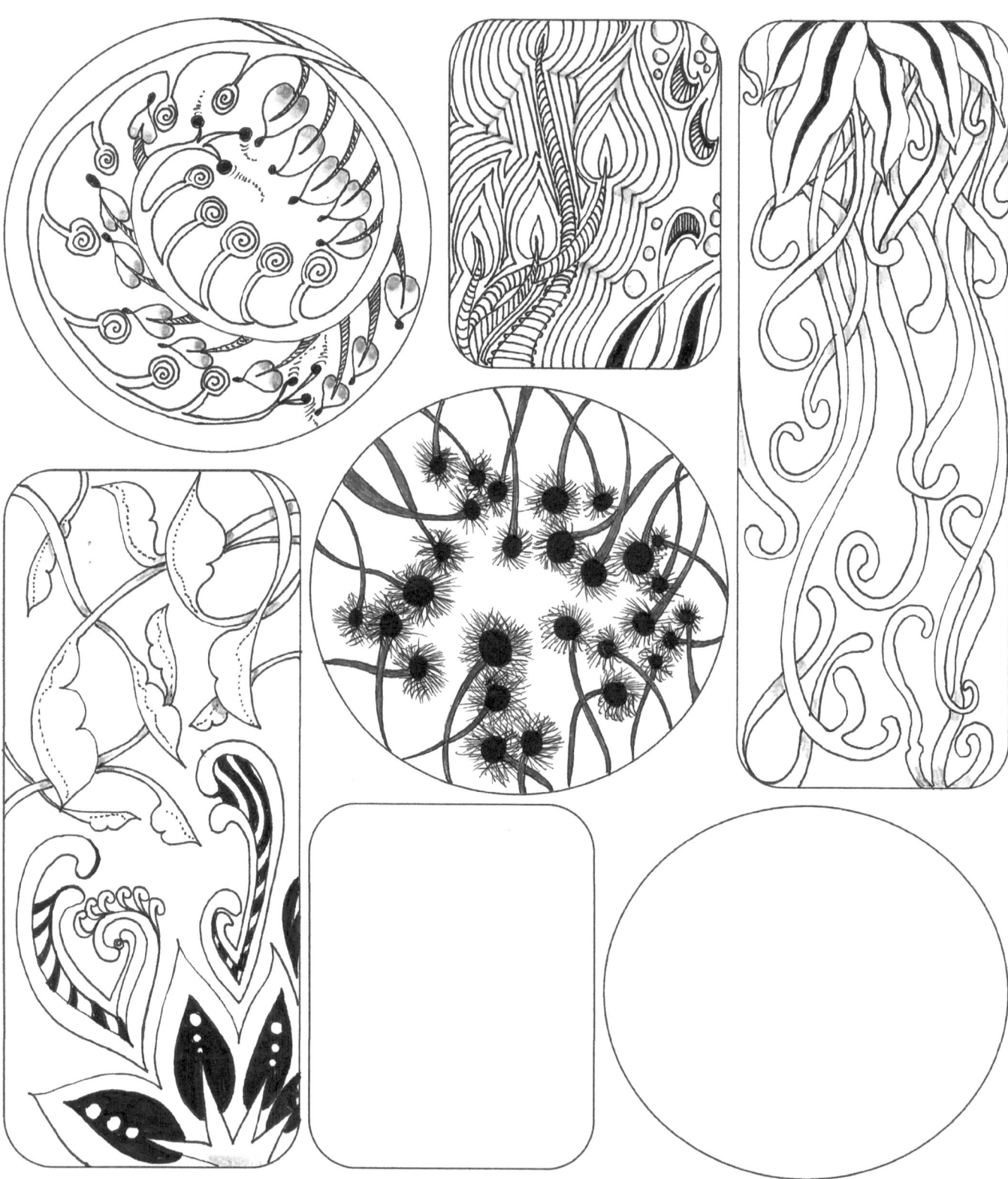

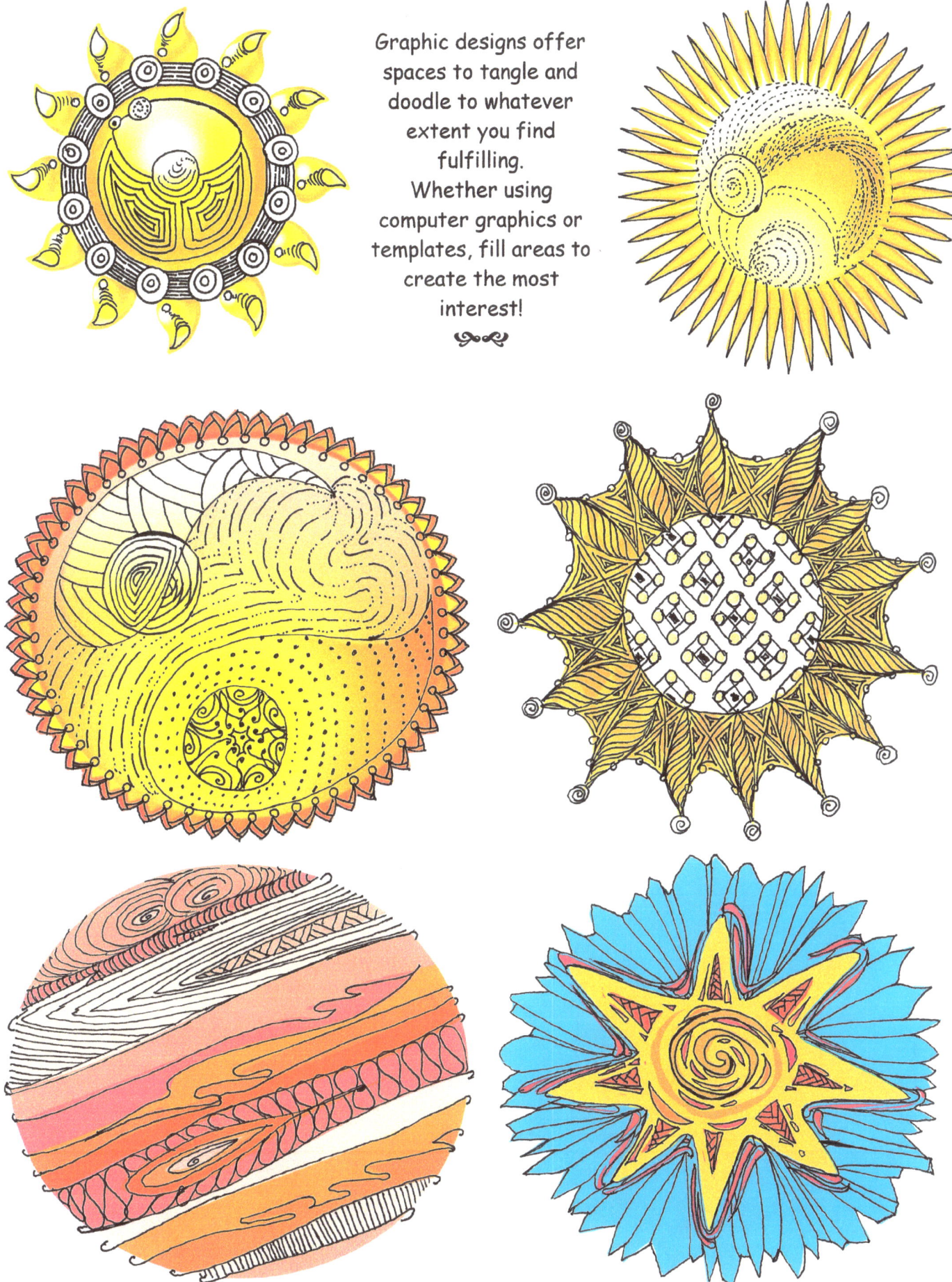

Graphic designs offer spaces to tangle and doodle to whatever extent you find fulfilling. Whether using computer graphics or templates, fill areas to create the most interest!

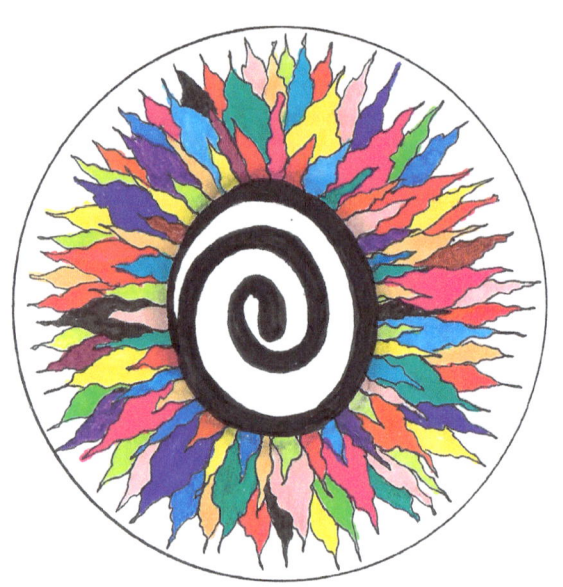

To execute this flame drawing, use the pen to first start with the outer circle. Place another circle or oval inside the large circle, centering (sort of). Add the swirl by making one single swirl line. Upon reaching the end (or the center, whichever way the line was started) add a second line next to it and fill in space between the two lines using the pen. From there, begin the smallest flames, tucking some behind others. Leave a small space between some of the flames to create interest. Each row should vary in flame size. Color the flames using markers, colored pencils, etc.

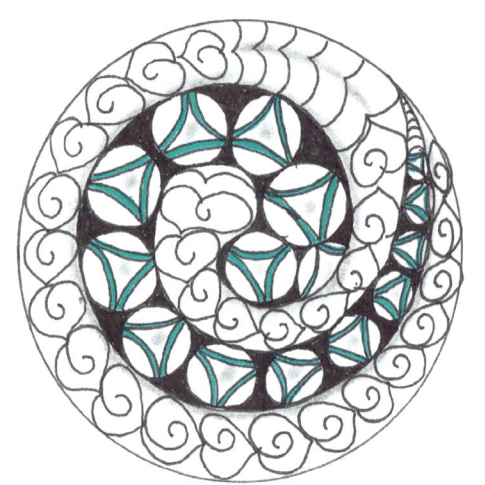

Create a circle. At the inside edge of the circle, draw a continual swirl line, ending where it began. This line will make two swirls, one inside the other. Add line work or embellishments that come to mind of use those here. Make sure to shade using the pencil and blending stump. Colored ink or markers can be used to add a touch of color.

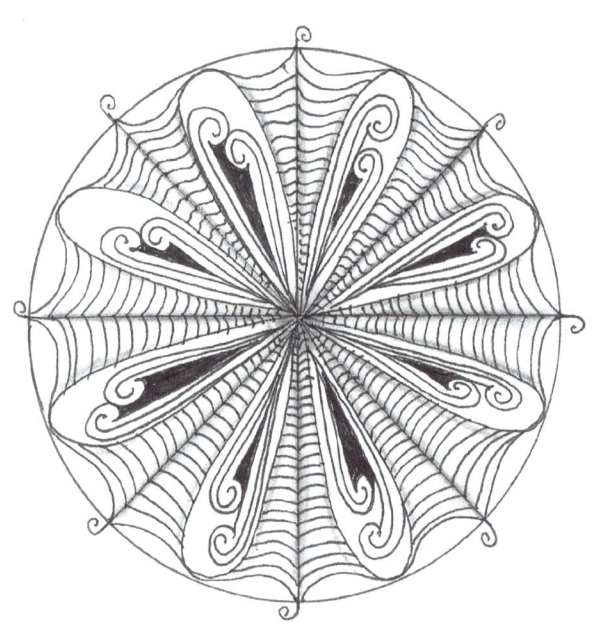

Start this drawing with the outer circle. Find the center using a ruler and mark it lightly with the pencil. Section the circle using the pen as though dividing it like numbers on a clock are evenly divided. Draw the petals in the center of the divided sections. Inside the petals, make two curled fern-like lines, one shorter than the other. Outline the fern lines and fill in the interior space with the pen. For the sloped lines between the petals, start at the center line and slope a line over to the petal. Continue until there is no space left. Shade along the outer lines of the petals with the pencil and along the center of the divided line to create depth. Add a curl at the top of the divided line using the pen.

Zentangle® is an attitude of mind and heart. It allows us to free our soul and renew our inner spirit.

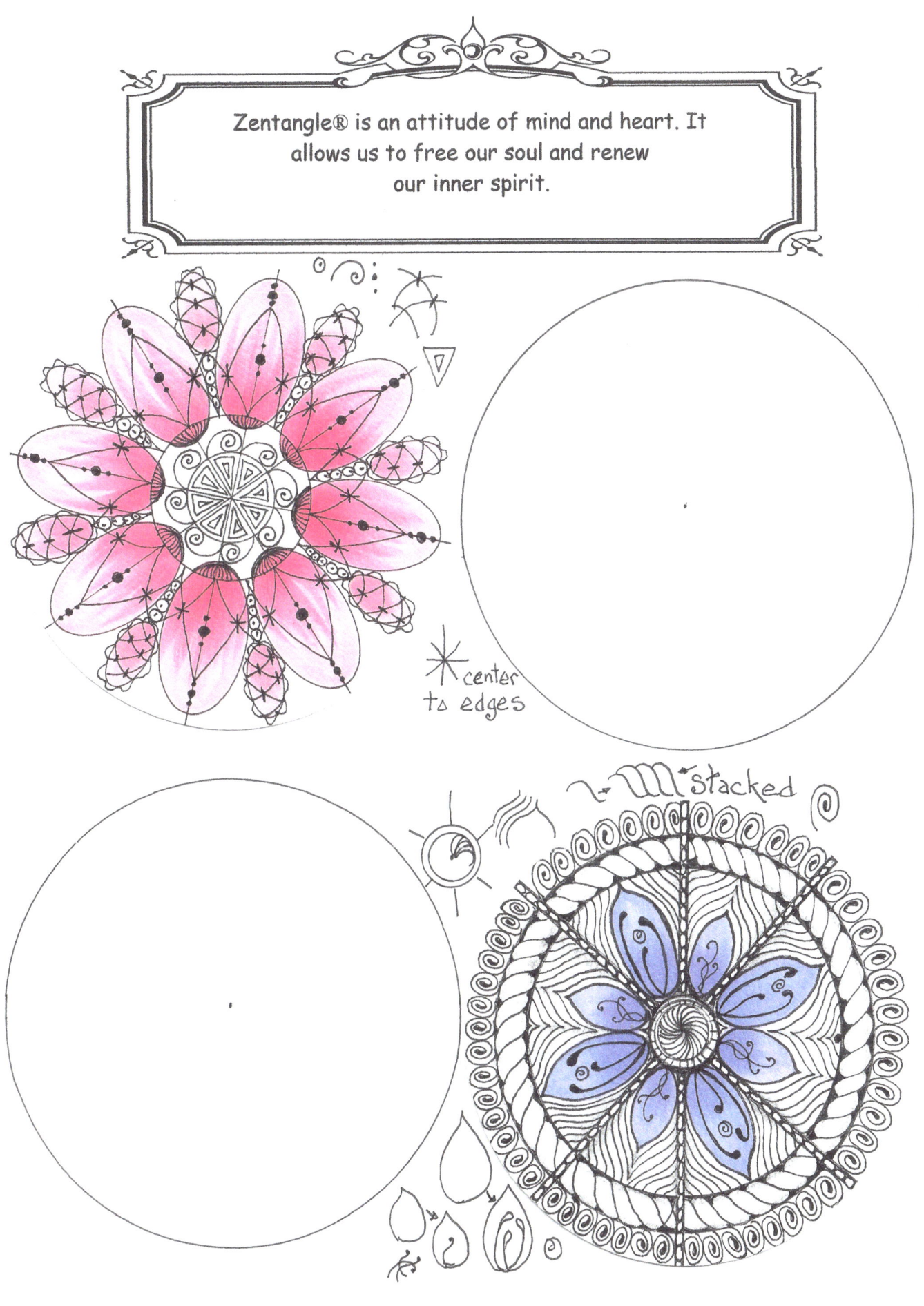

Celtic Designs in the Round

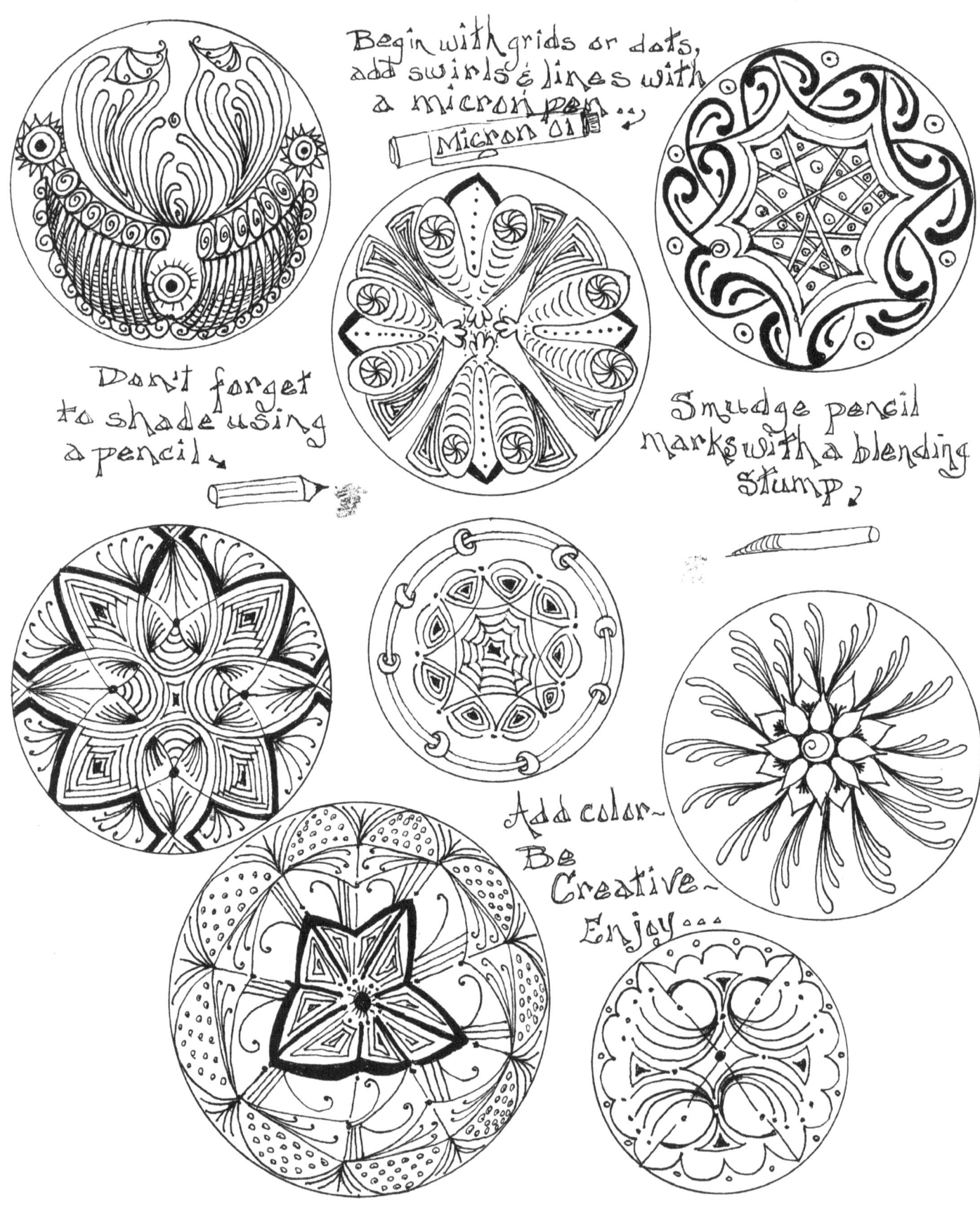

Tangled tiles or pieces of them, in color or simply black and white, generate amazing designs that can be kept and framed as art.

If using Copic® markers to color backgrounds or the design itself, try not to go too close to the line edge in case the ink bleeds. To add an effect, use the Copic blender marker. It moves color and will delete it by pushing it outward from where the tip sits on the paper. Copic markers are alcohol ink based as is the clear blender.

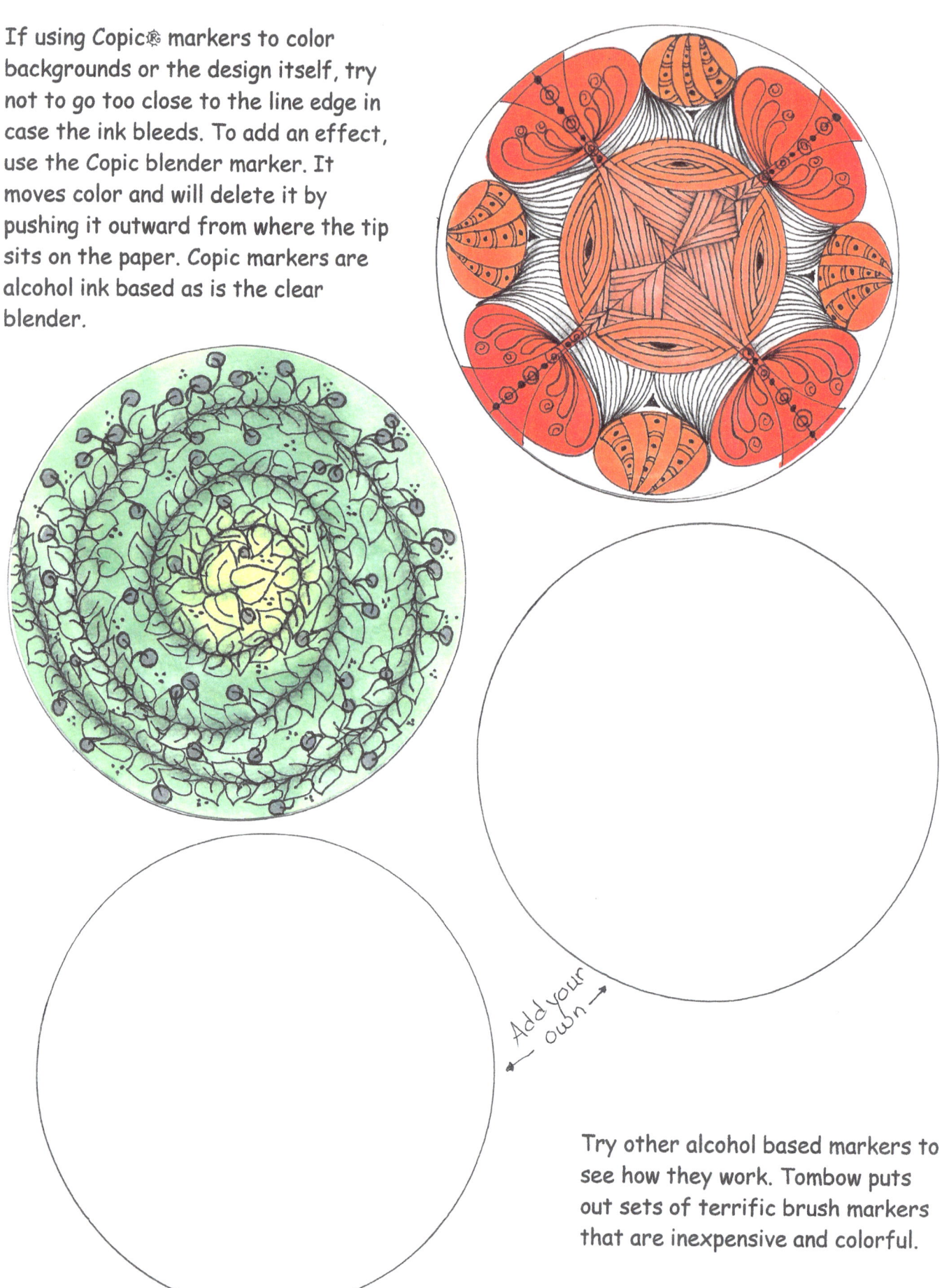

← Add your own →

Try other alcohol based markers to see how they work. Tombow puts out sets of terrific brush markers that are inexpensive and colorful.

Capture the essence of tangling by repeating patterns. Repetition allows us to relax, and our focus to become deeper.

Once a tangle takes shape and shading has been applied (a little or a lot), a sense of accomplishment will follow. Set the tangled design aside for a while. Later on, look at it with a fresh view. It's beautiful, isn't it? Turn it upside down to view it from different perspectives. The tangle changes each time.

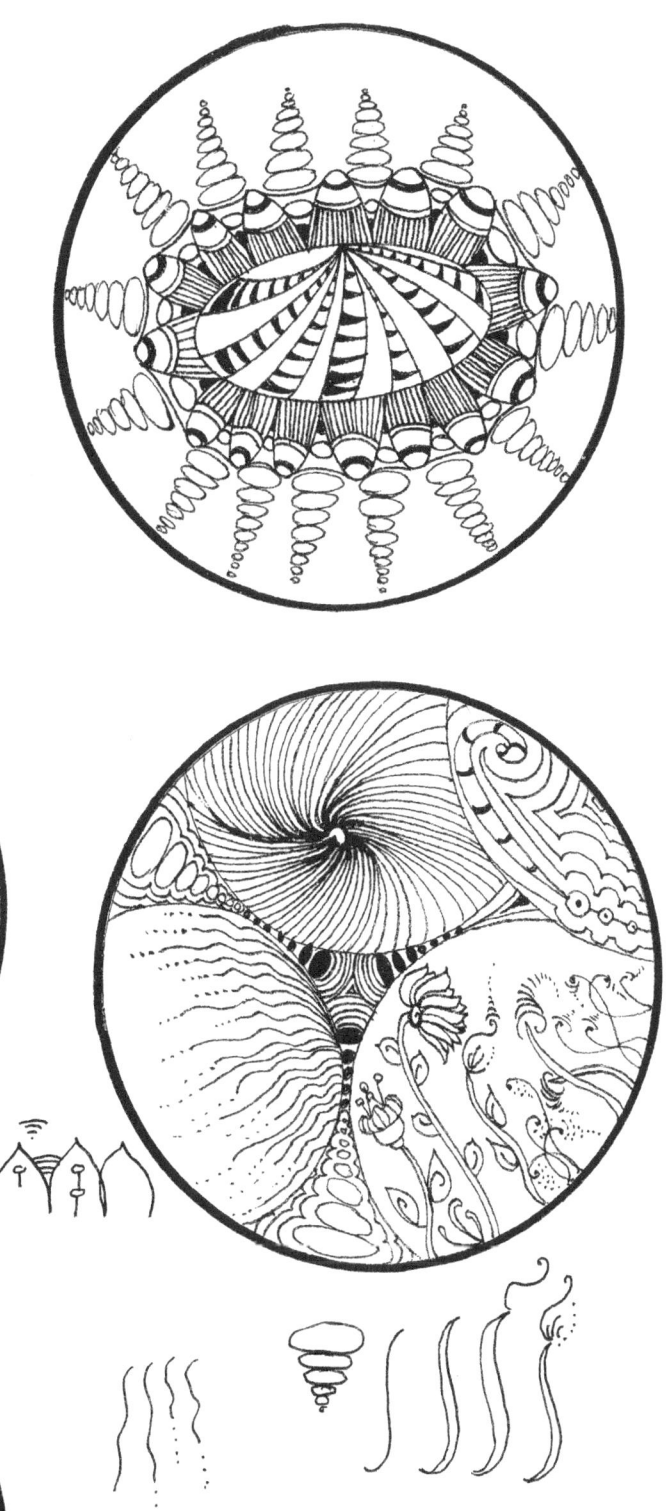

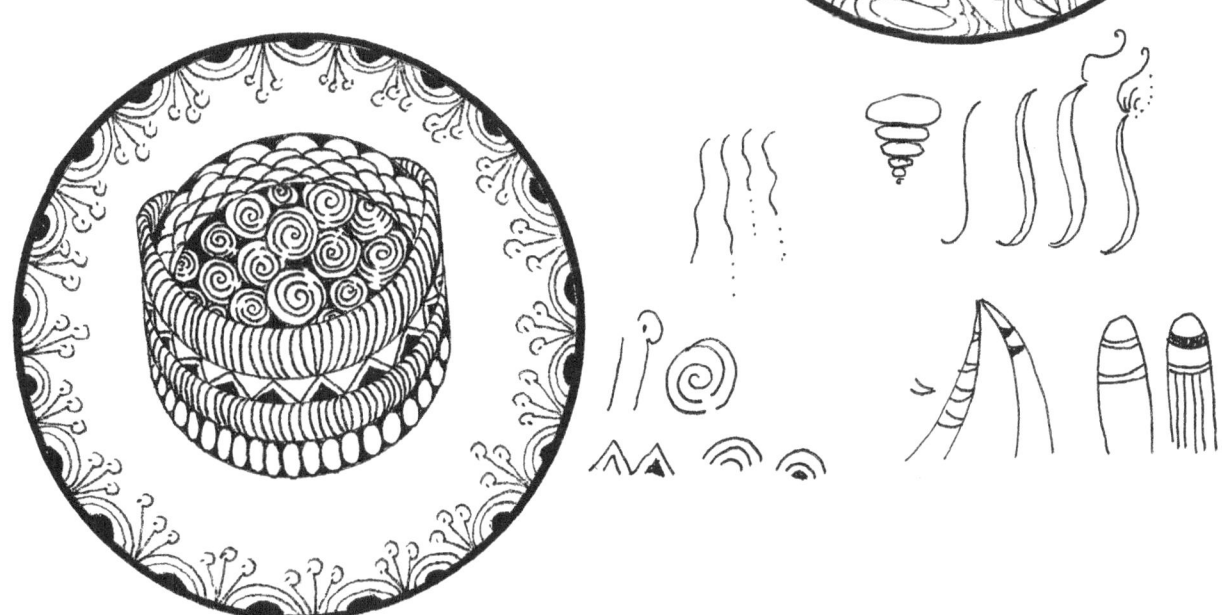

Another interesting way to create a unique background to tangle on is to moisten the tile with water, add color and then drip rubbing alcohol onto the wet paint. The color will bloom (spread out) as the alcohol pushes its way in. Let the paper dry before using a white Sakura gel pen to add tangles to the tile.

Tip: Use a blow dryer for a faster drying process.

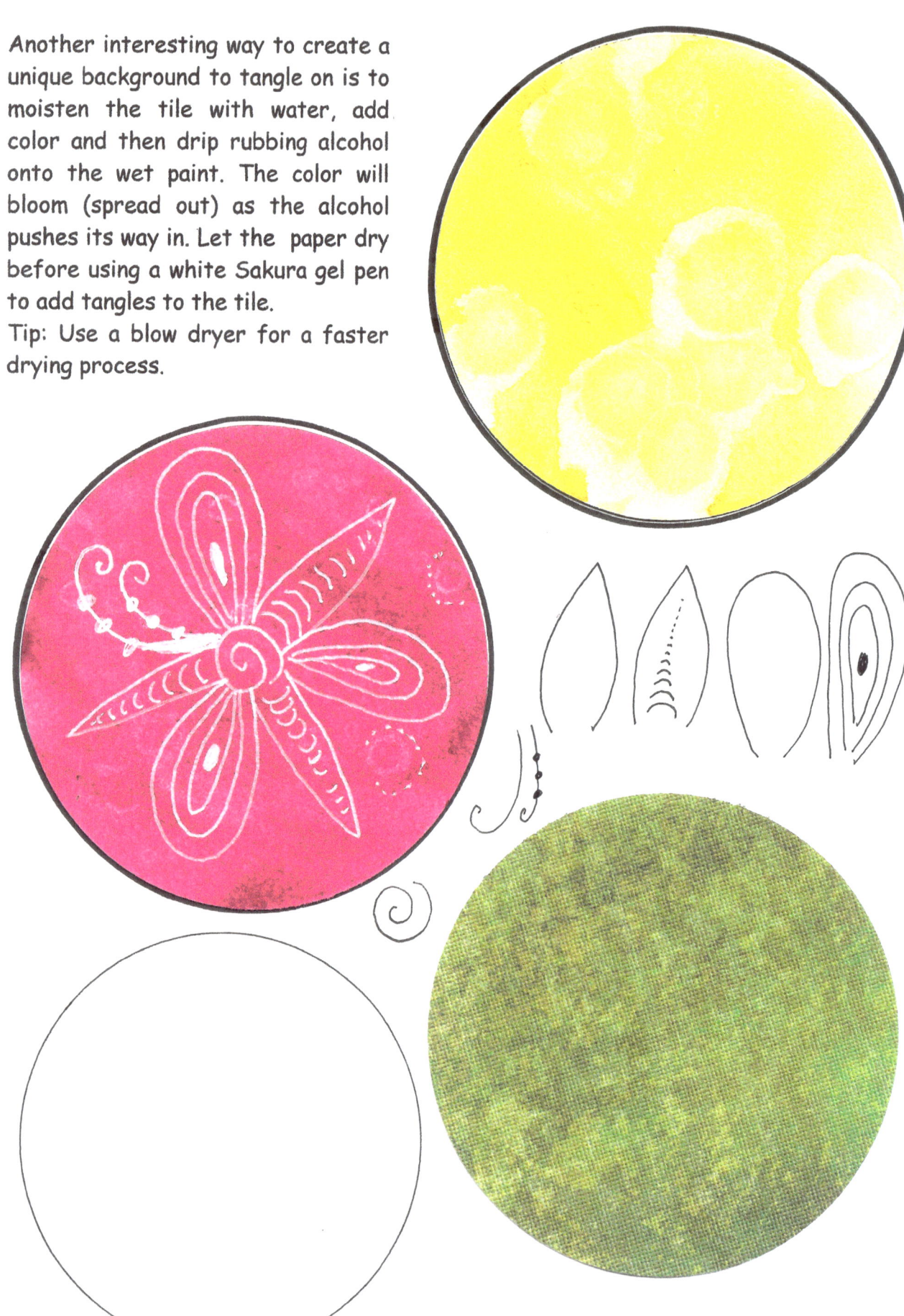

Impress a round tile using a stylus or a pen that has no ink in it, or an embossing tool (much like a stylus), A wooden dowel that has been sharpened using a pencil sharpener works, too. Press the tip into the paper to make lines, circles, or whatever design comes to mind. Use pastel pencils or colored pencils to color over the raised areas. The impressed design will show in white against the colors.

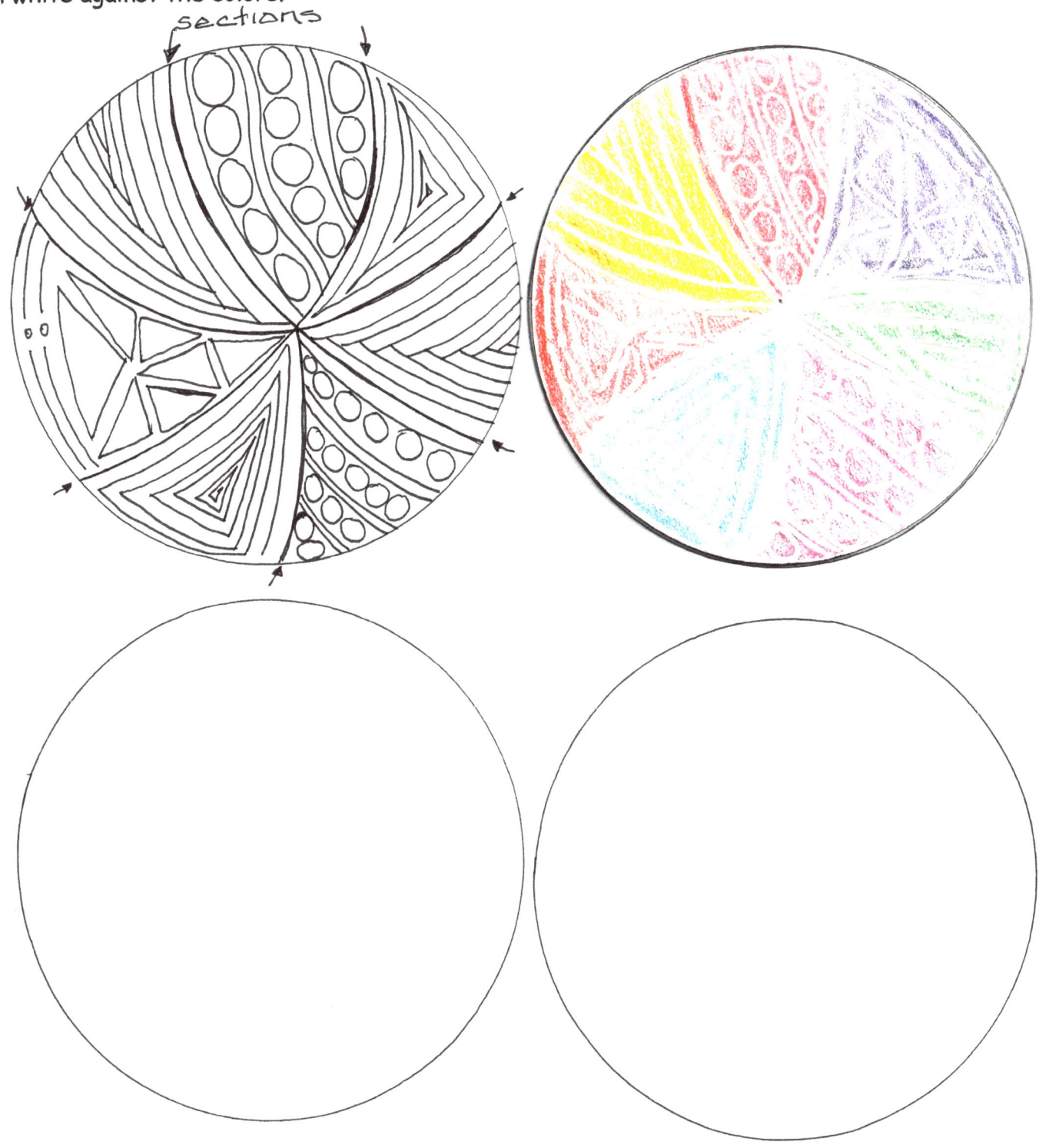

Instead of working from the inside out, try working from the edge toward the center of the circle to see what happens. There are no mistakes, only possibilities when tangling. Fill these open spaces and enjoy tangling.

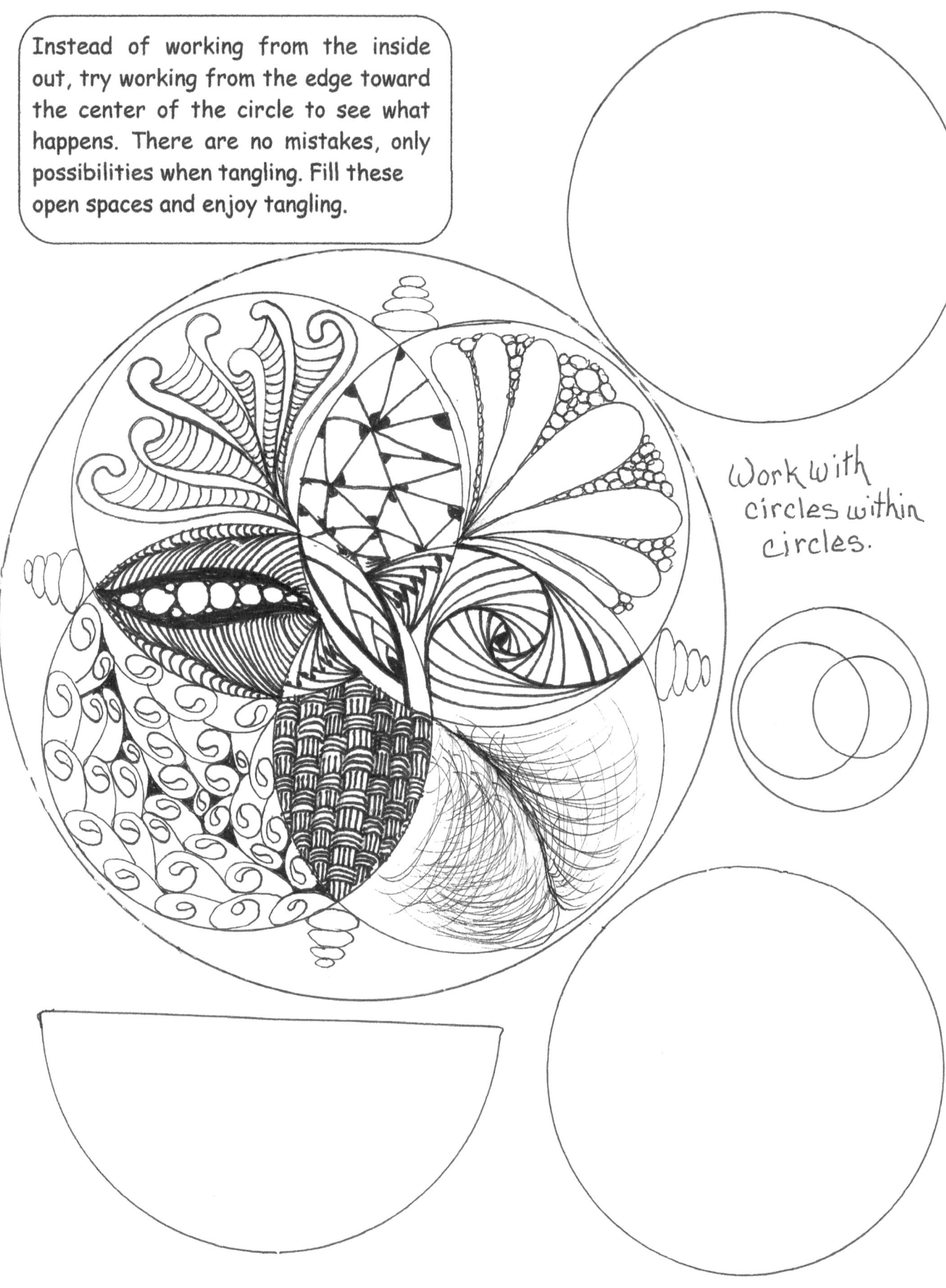

Work with circles within circles.

To add texture to a tile (a round or square piece watercolor of paper), wet a sponge with water and moisten the paper by wiping the wet sponge across it. Dip the sponge into acrylic or watercolor paint and pounce the sponge up and down on the palette so the color softens into the sponge. Press the sponge onto the paper and watch what happens. Try multiple colors for variation.

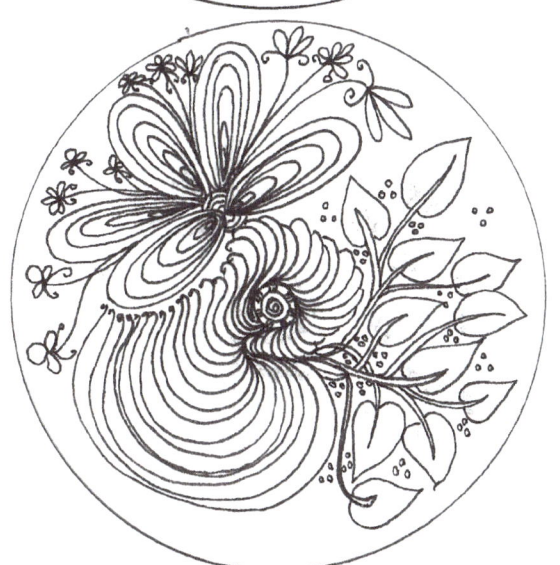

Organic Designs

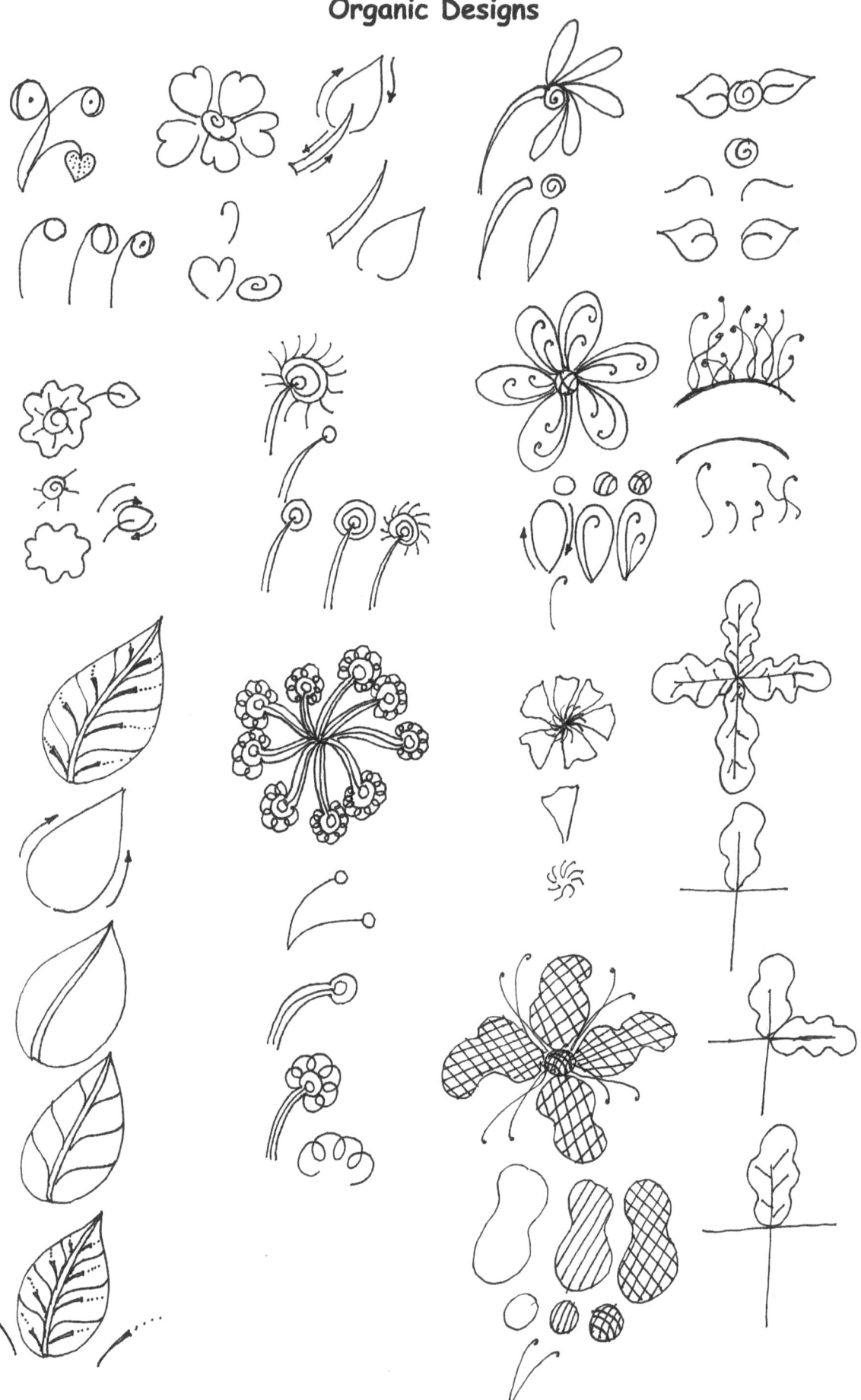

Step-by-Step Instructions
Use these samples to help create organic designs.

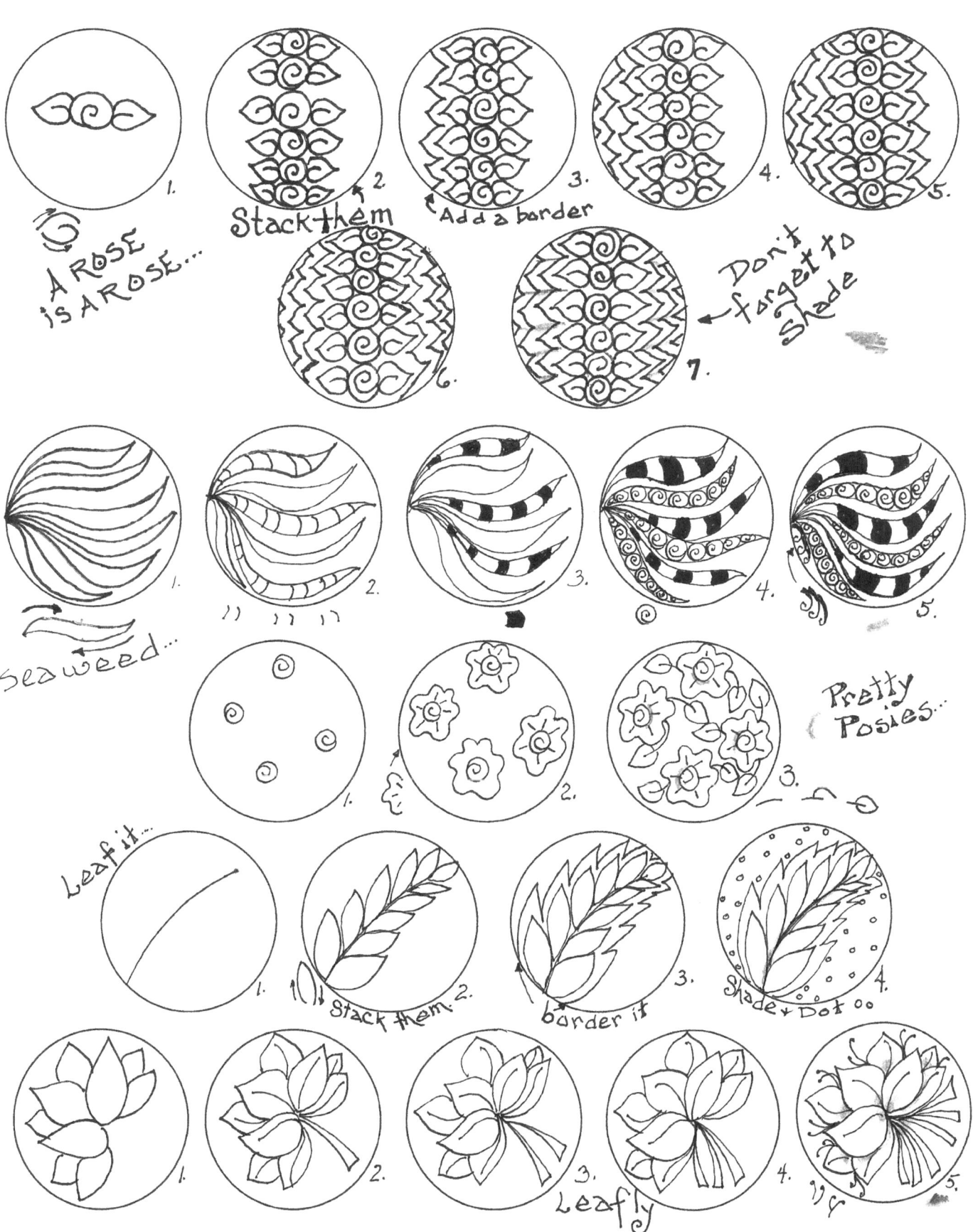

When there's an open mind, there will always be a frontier. Have an open mind when it comes to tangling. Let your imagination rule, and the limits are endless. A closed mind allows a narrow view. Open up your possibilities, free your spirit, and let your creative juices flow. It's not harmful, but healthful!!!

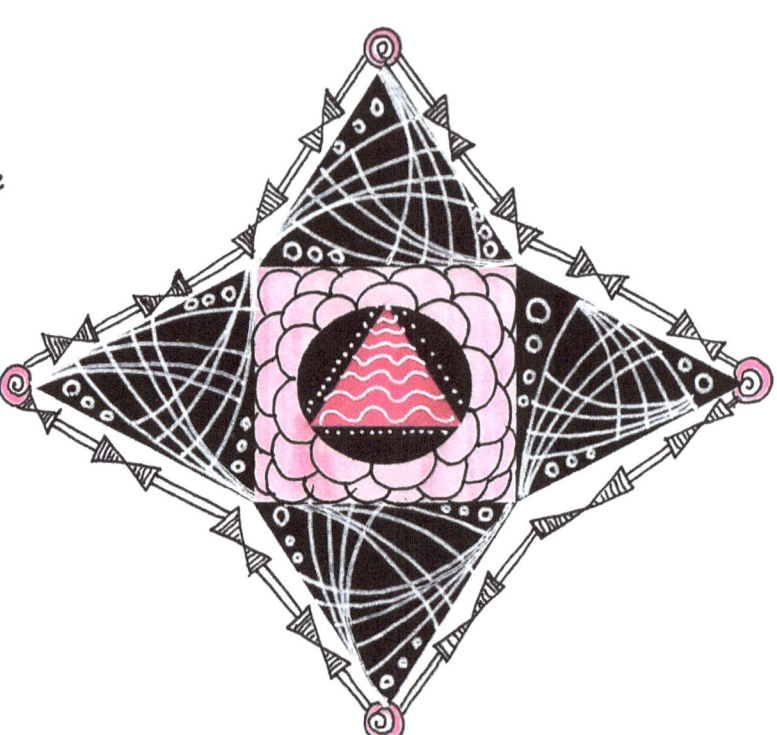

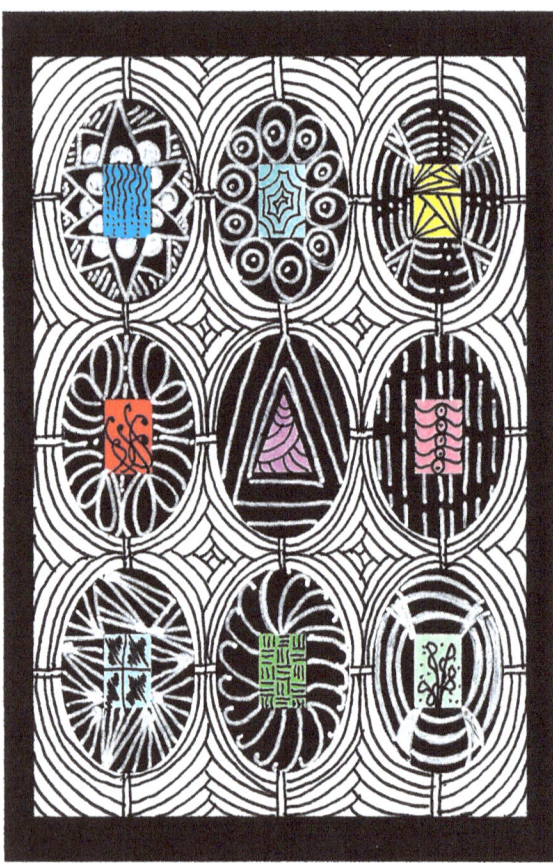

We can't do everything at once; but we can do something at once.
Tangle Daily!! It's good for you!!!!

Choose to tangle, it will make life more pleasant. ♥

Step-by-Step Instructions
Use these samples to help create round Celtic designs.

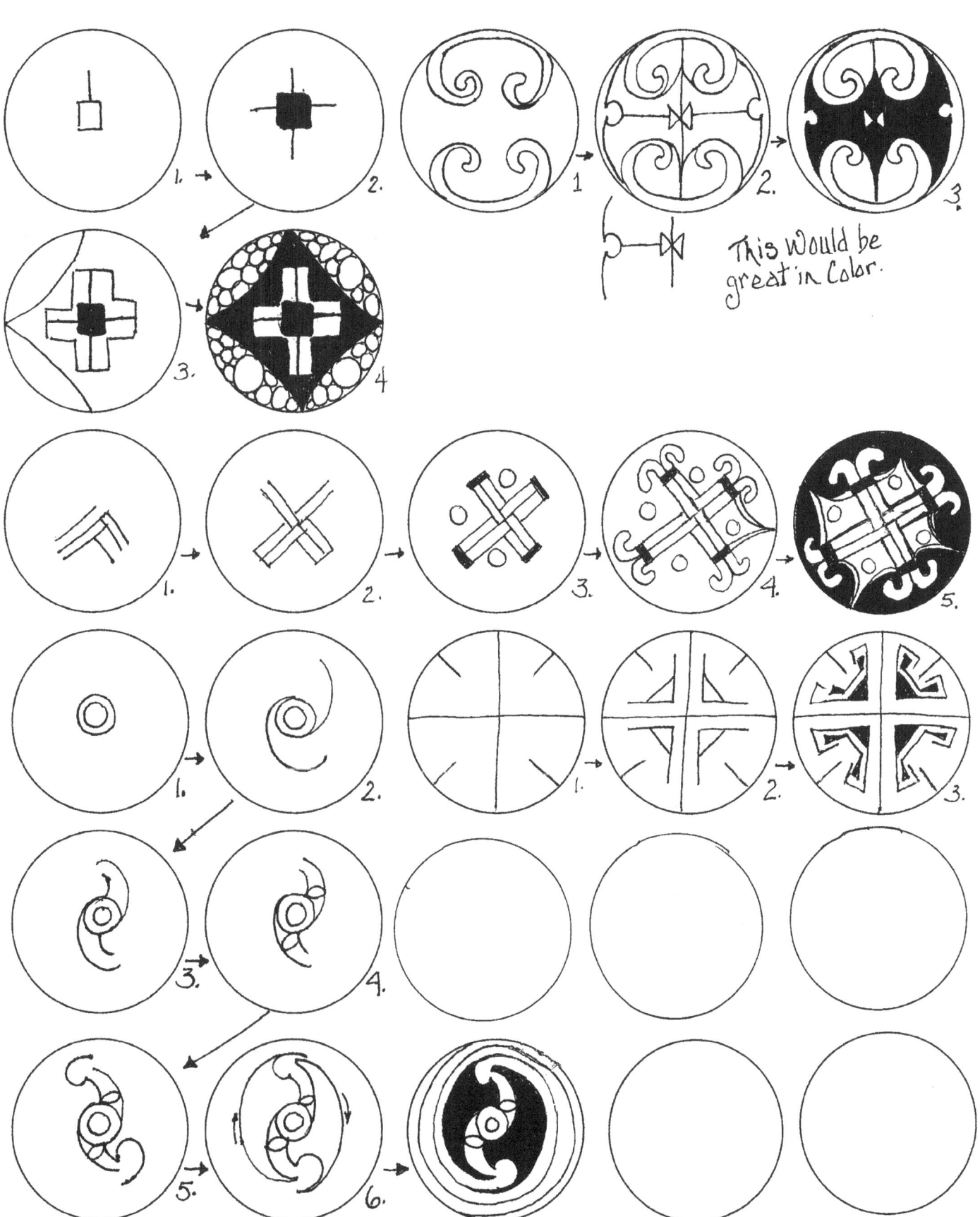

This would be great in color.

21

A study has proven the benefits of Zentangle. It's considered a mindful art form, meaning it helps your brain relax, which helps your body to do so as well. As your tangle progresses, so does your mind, allowing it free itself of what is causing your stress. Solutions then can present themselves. I'm no psychiatrist or a doctor of any kind and not all problems are that easily solved. I simply know the benefits of tangling, that it works for me and it can work for you, too.

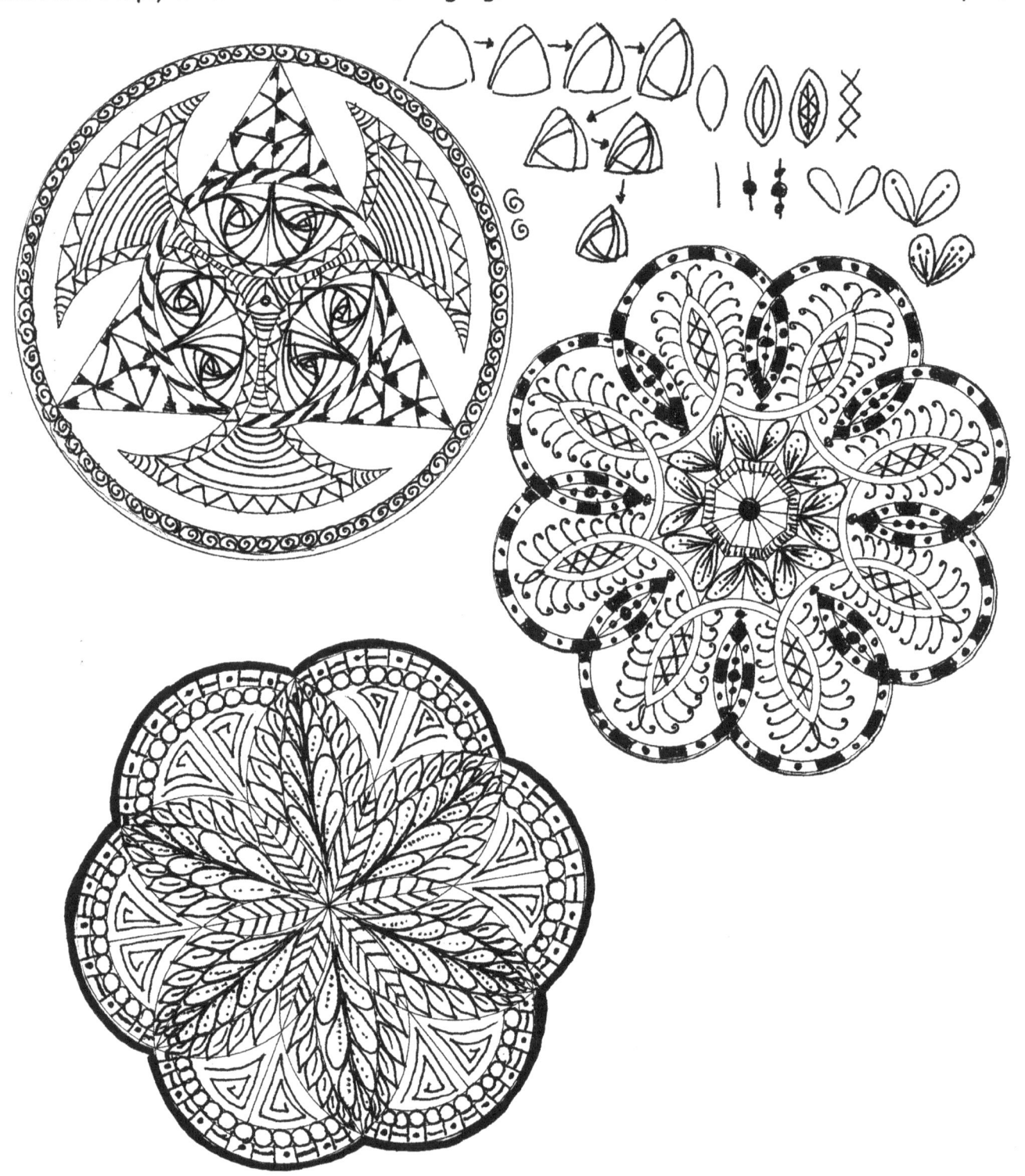

Take time to tangle daily, even for a short while, it's well worth the relief you get from stress.

While Jenna was ill, she spent time creating art with her mom and brothers. Jenna was a girlie-girl who loved shopping, art, and most of all her family. A fashionista, Jenna sought out the latest in fashion right down to her head bands, which she wore all the time. Here are some designs for headbands and bracelets that will delight any child, especially one who is ill. ☺ ◯ ◐ ◉ (use a Sharpie® pen on cloth or plastic.

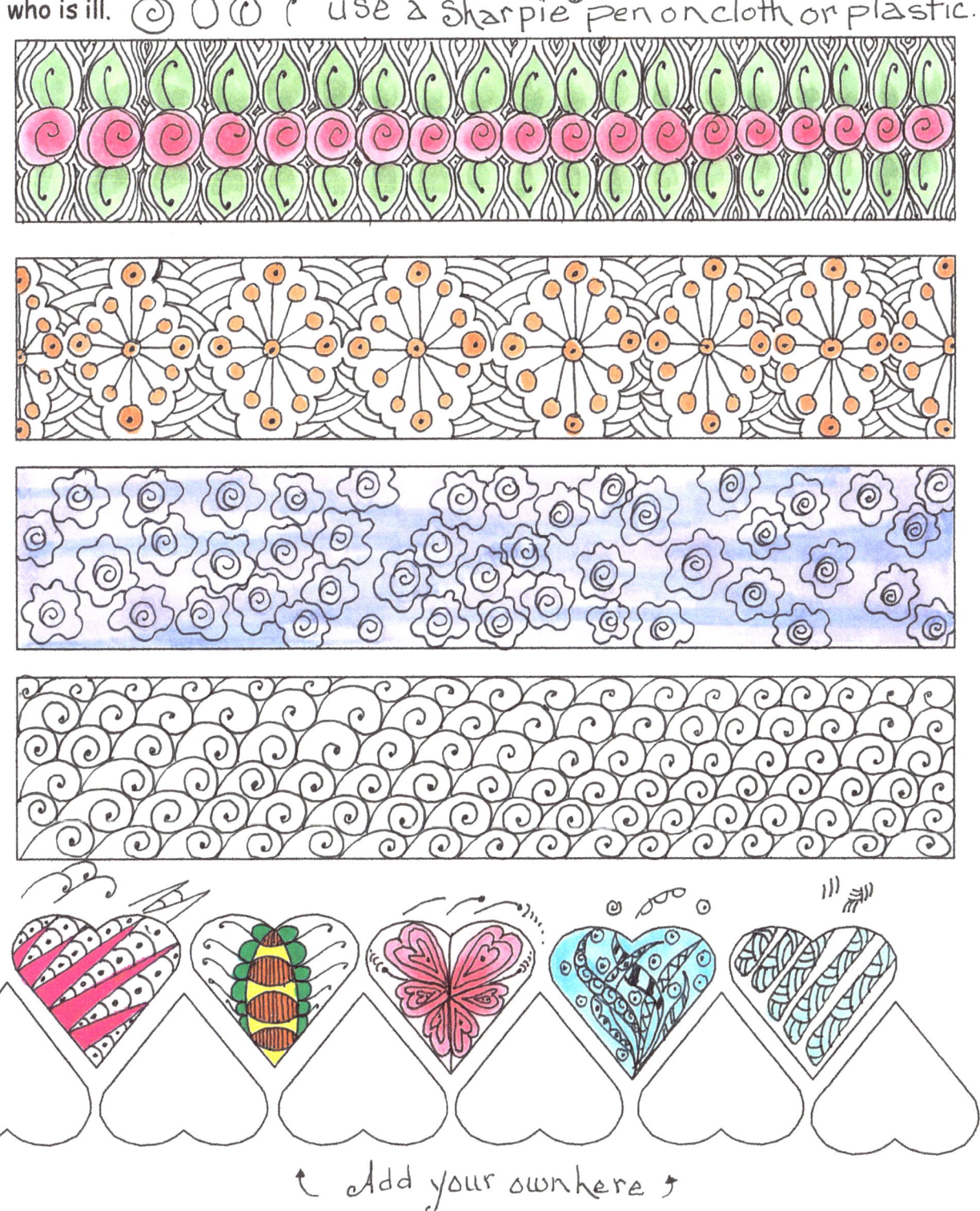

← Add your own here →

When you see a child with cancer, smile and say hello. Most of all, <u>Don't Stare</u>! They're already self-conscious enough and don't need to feel worse than they already do.

Have you ever heard the term, "When in doubt, work it out?" With tangling, I say, "When in doubt, tangle it out!" It's not work and is much more fun!!!! (I promise)

The best thing about Zentangle is....

THERE ARE NO MISTAKES... ONLY OPPORTUNITIES

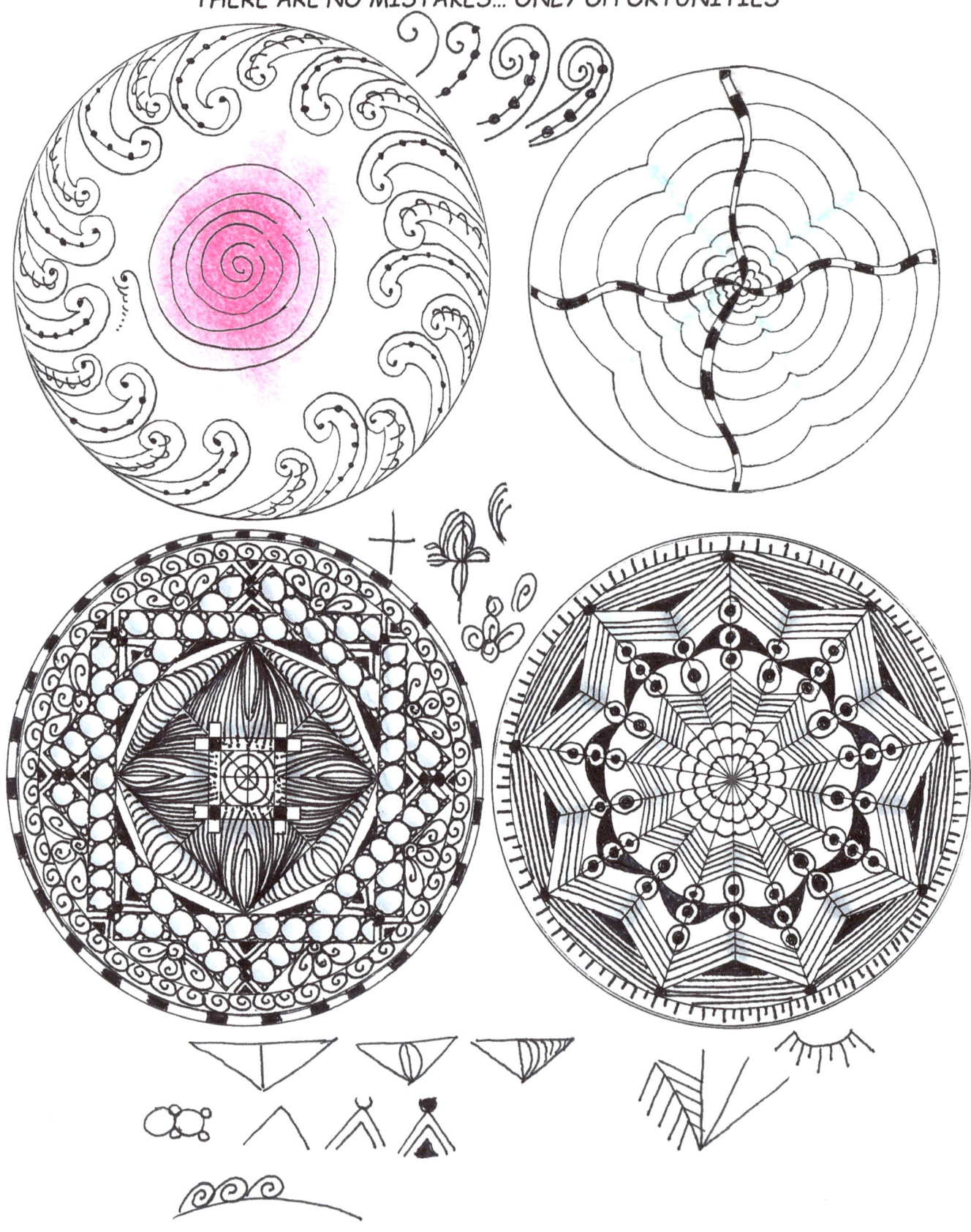

Not long ago, I wrote a mystery novel, "Tangled to Death" (as J.M. Griffin), which was centered on tangling and its benefits. When I had it formatted, my formatting guy used tangles to separate scenes. Now why didn't I think of that? I heard from some of my readers that they hadn't known about Zentangle until they read the book. They wondered why I hadn't included more tangles at the end or at the beginning of the chapters. When readers speak, authors should listen (only to positive suggestions, mind you, not negative drivel) so the next novel in the series will have more tangles in it. I mention this because it's important to authors of any kind to hear from their readers, whether it is an art book or a novel of any type. We appreciate positive input, suggestions, and above all, we enjoy hearing from readers.

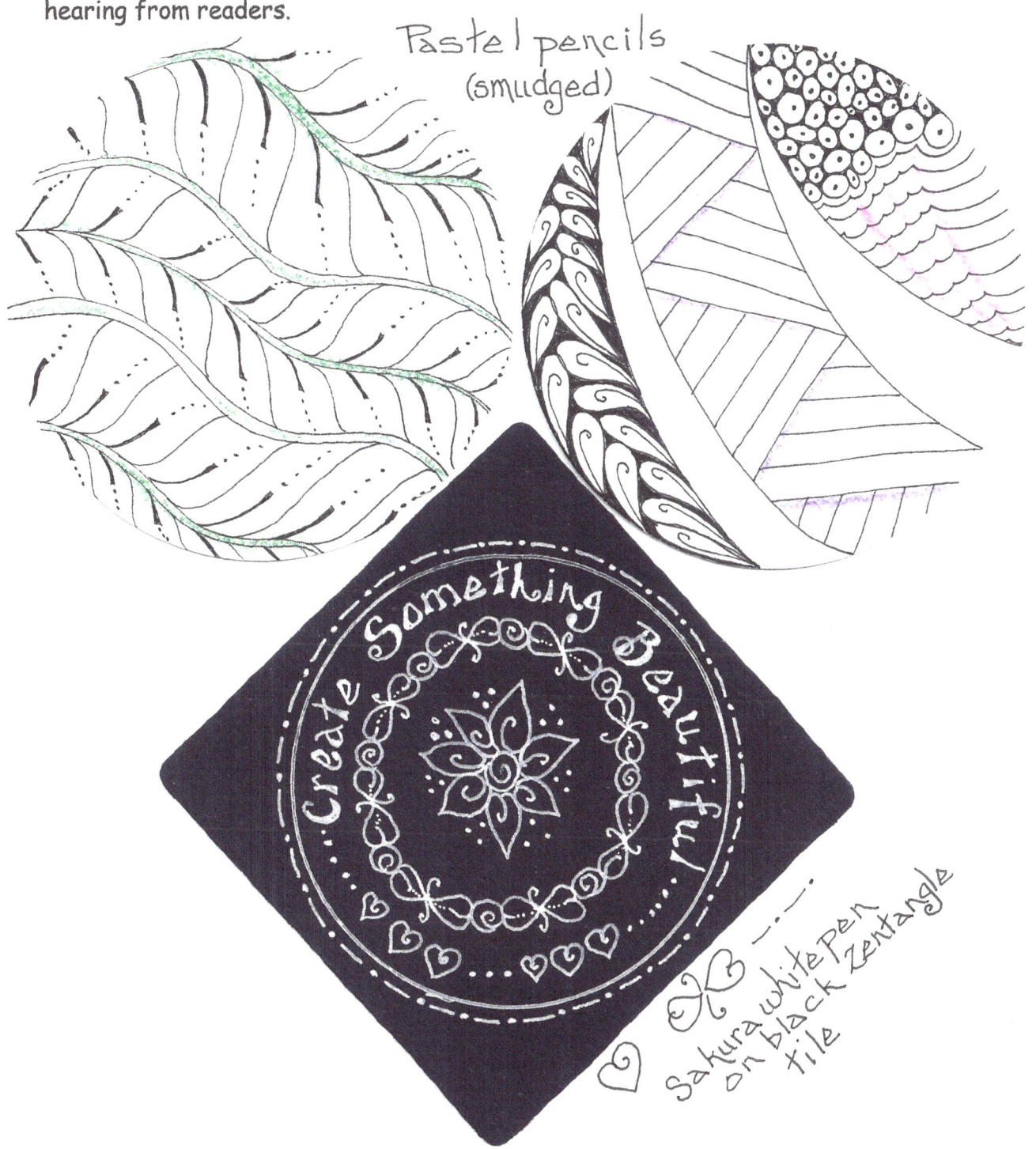

Coaster blanks from www.Smartrubber.com are perfect for stamping. 3 1/2" squares or rounds that are 3mm thick and are available in white. Add some clear laminate to them so they last a long time. Add your designs to the blanks below.

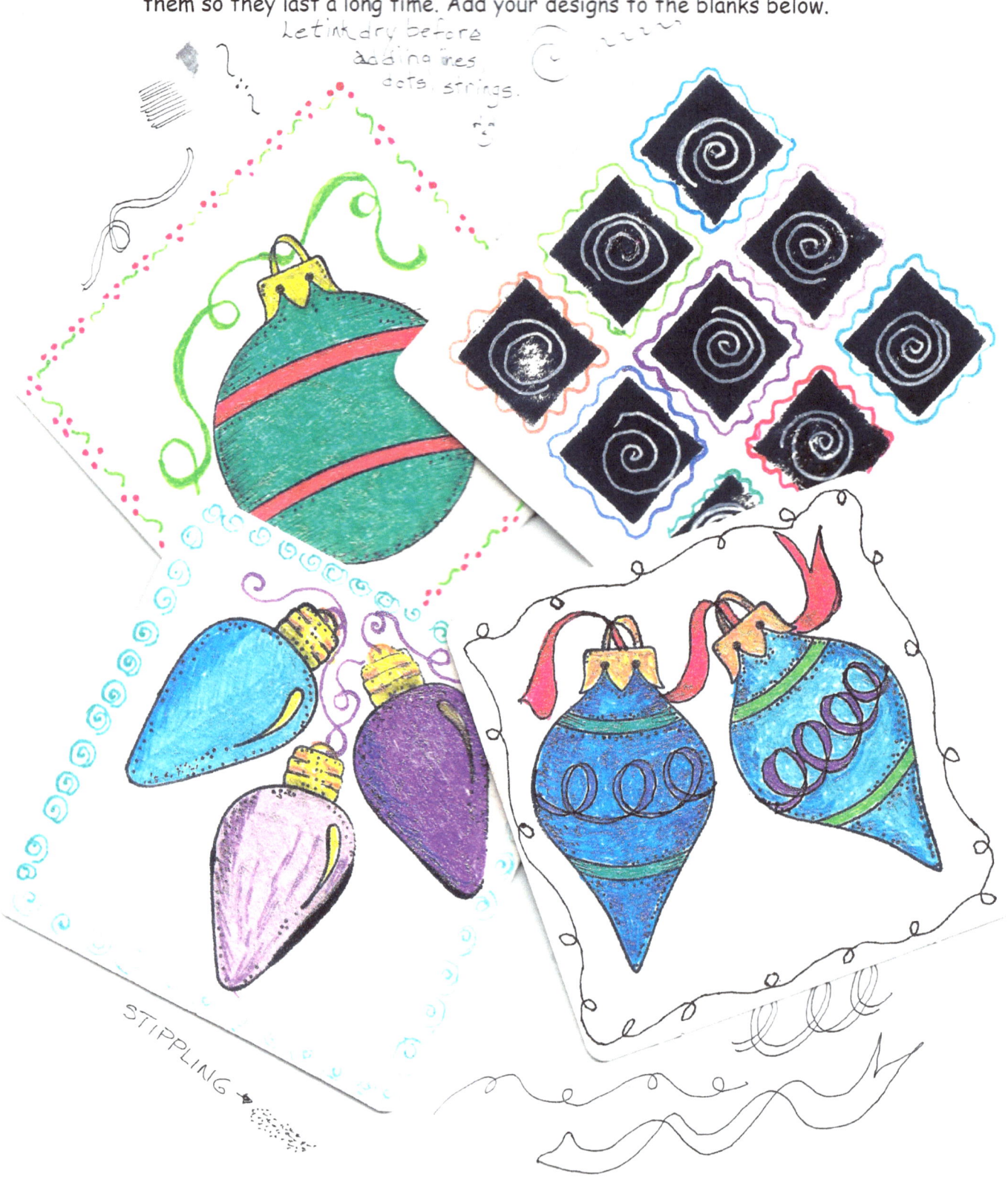

Basic tangled shapes!

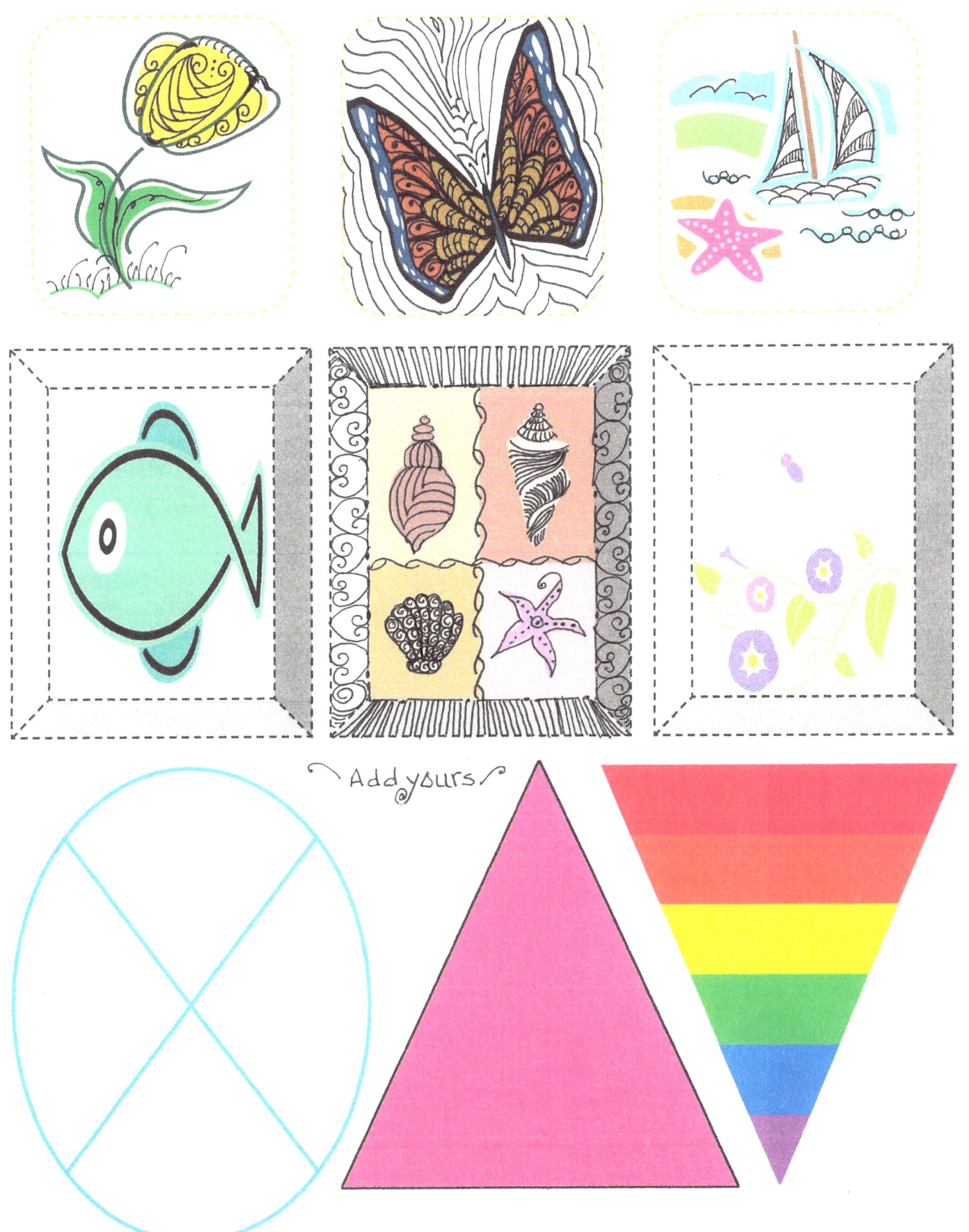

Add yours

Basic shapes for tangling!

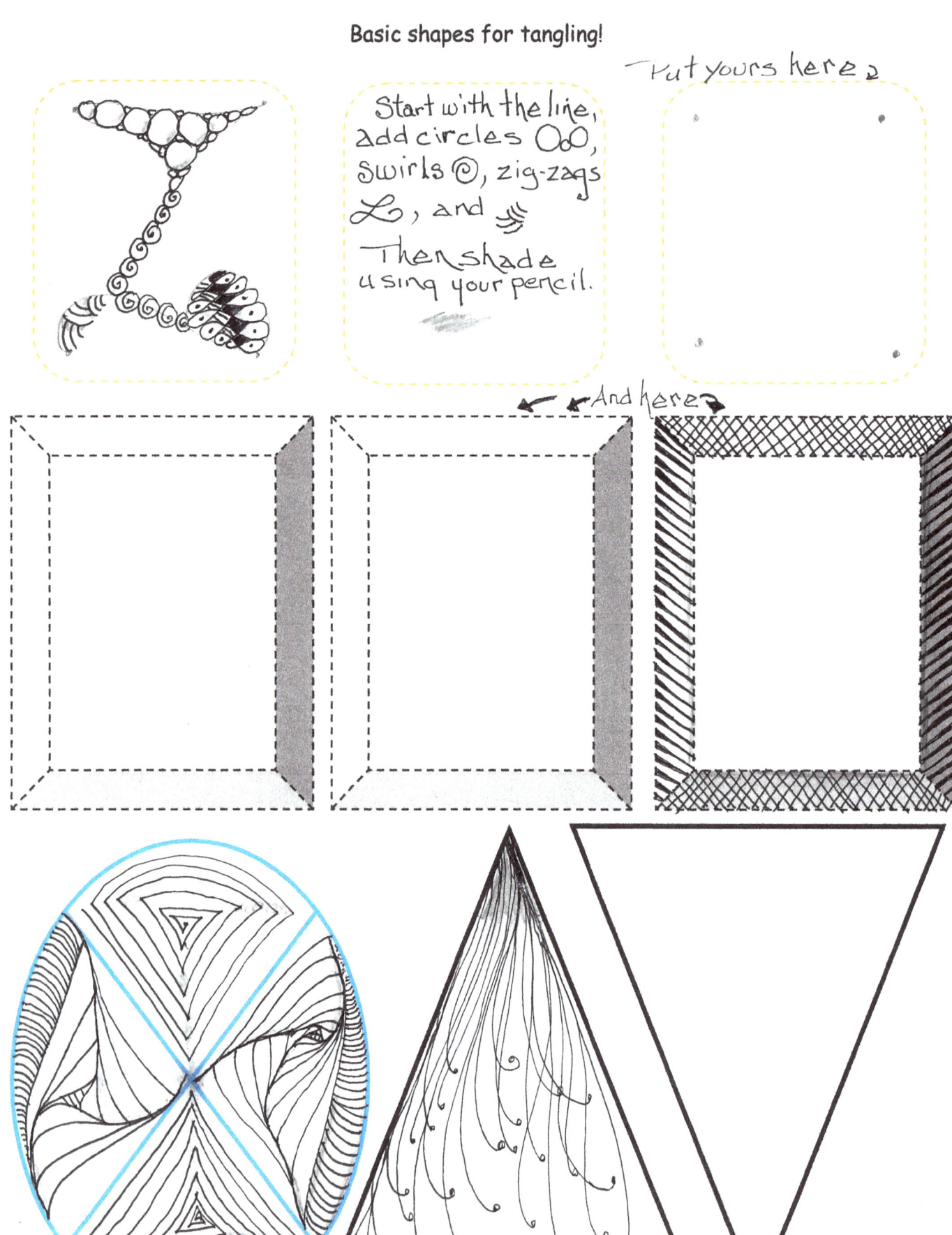

Start with the line, add circles ⚬⚬, swirls ⊙, zig-zags ℒ, and ⋙
Then shade using your pencil.

Put yours here →

← And here →

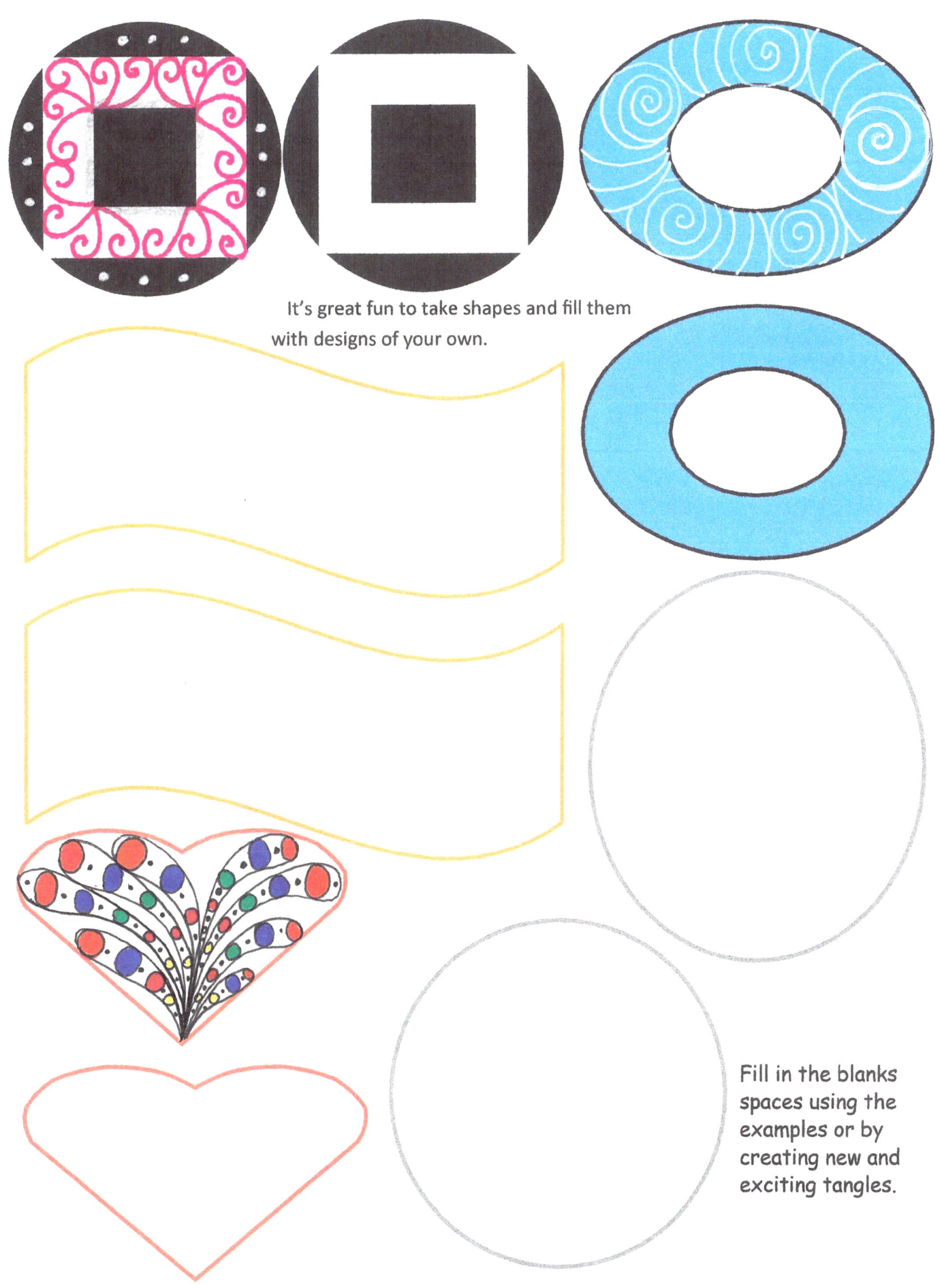

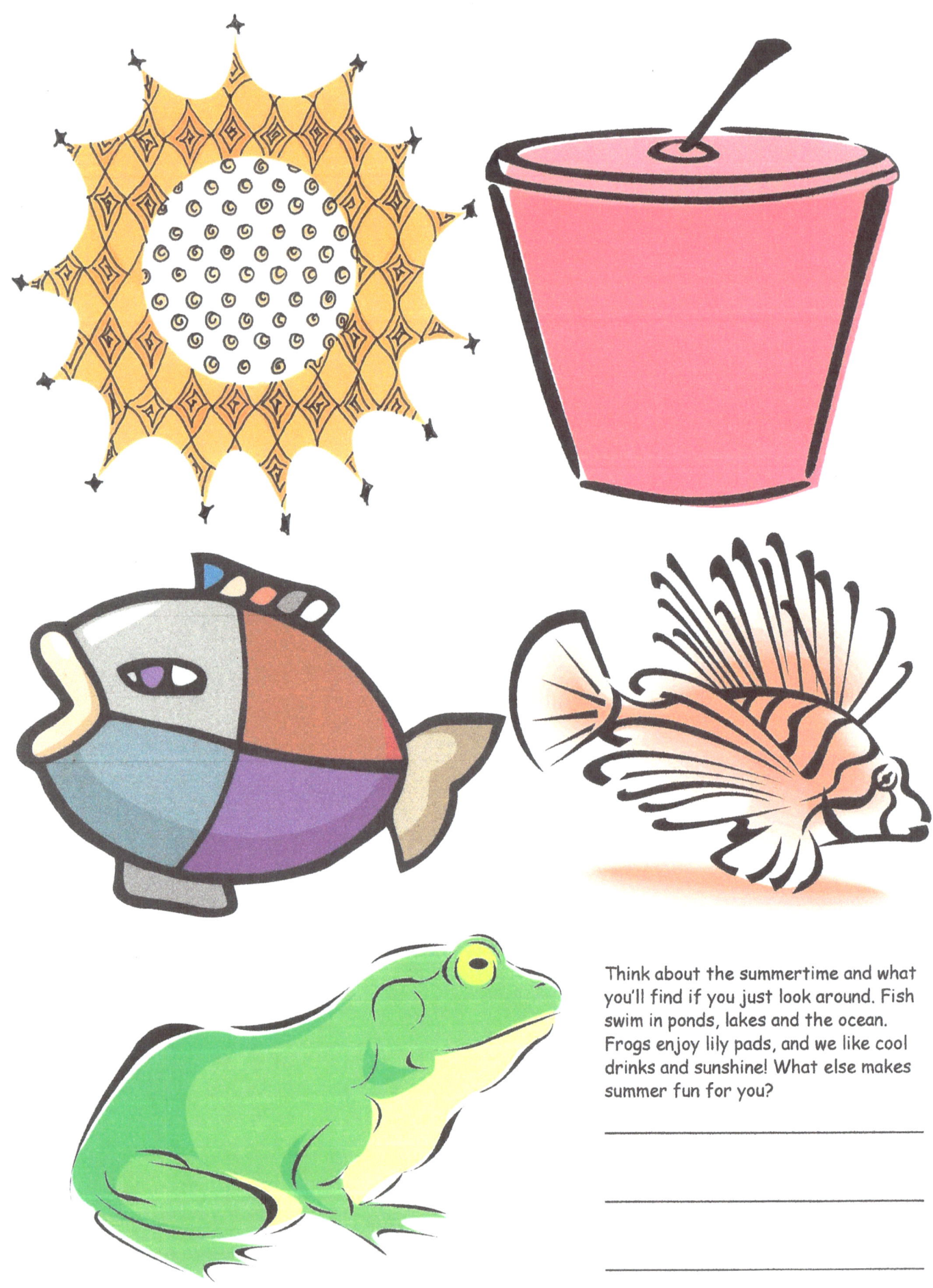

Think about the summertime and what you'll find if you just look around. Fish swim in ponds, lakes and the ocean. Frogs enjoy lily pads, and we like cool drinks and sunshine! What else makes summer fun for you?

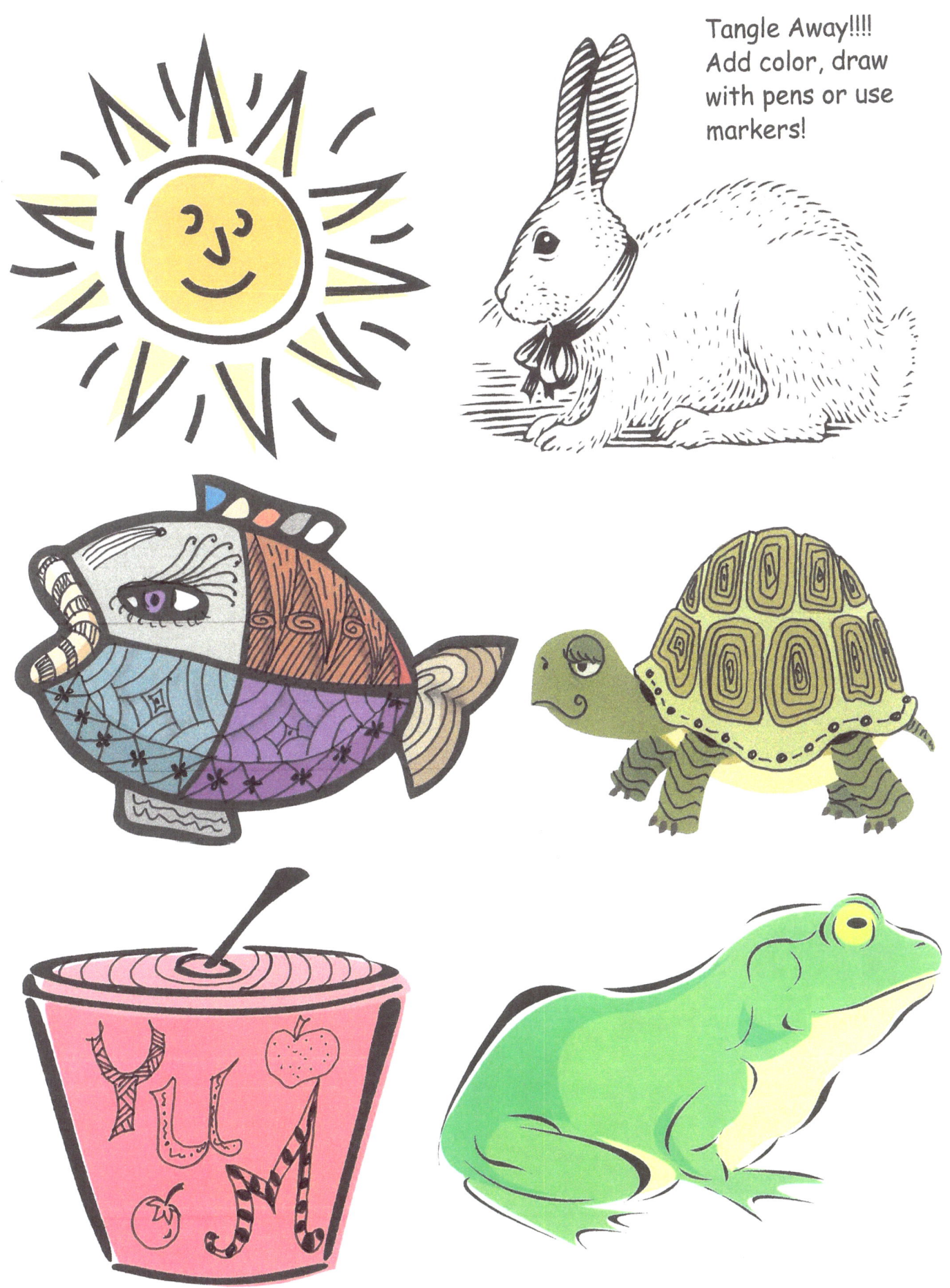

Tangle Away!!!! Add color, draw with pens or use markers!

Fall leaves are brightly colored. Each variety of tree has its own shape and color. Pumpkins, pears and apples are ready to pick. Tangle these.

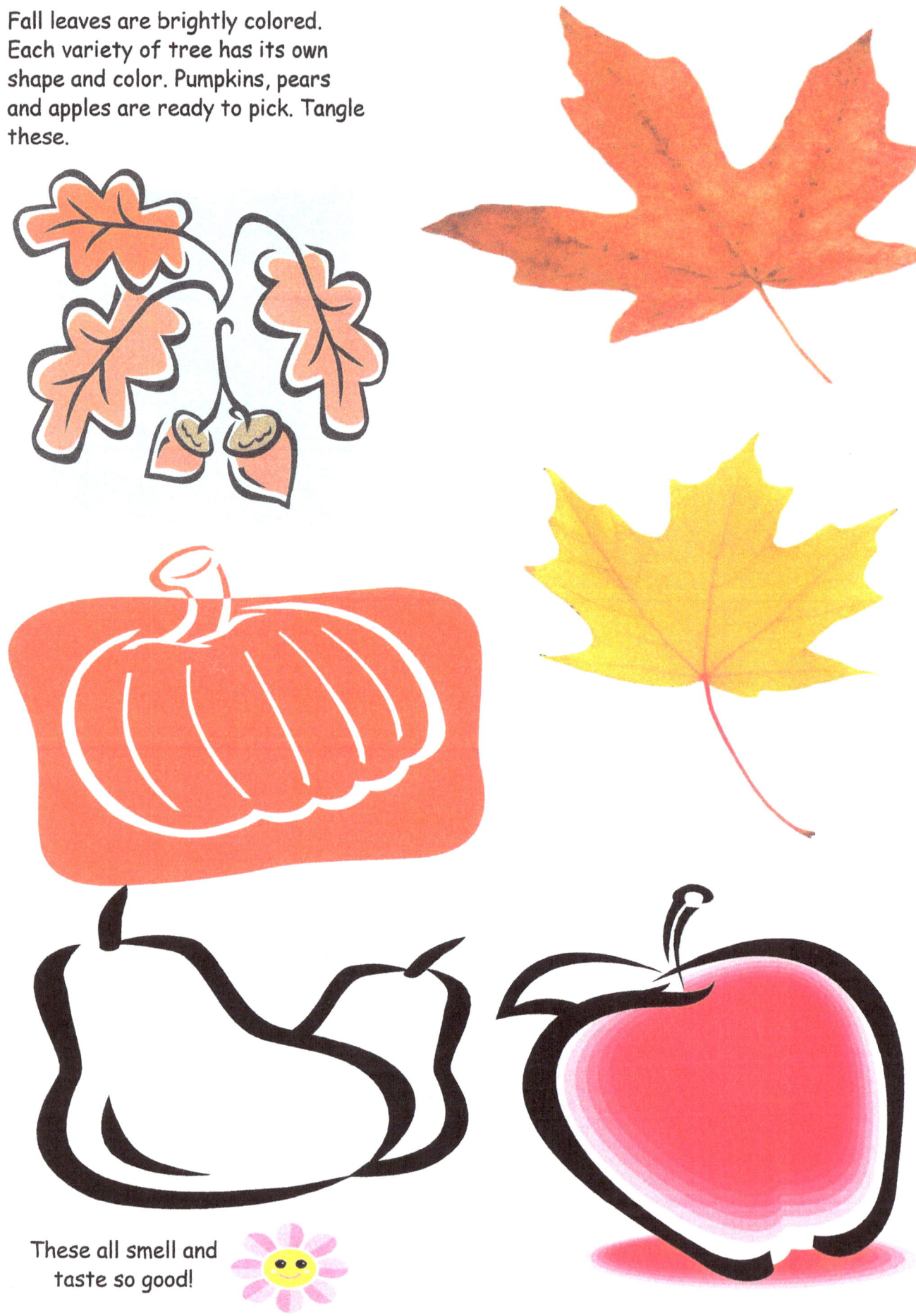

These all smell and taste so good!

One of my favorite times of day to tangle is before bedtime. Even if it's for a brief period of time, tangling helps me relax and unwind after a busy day.

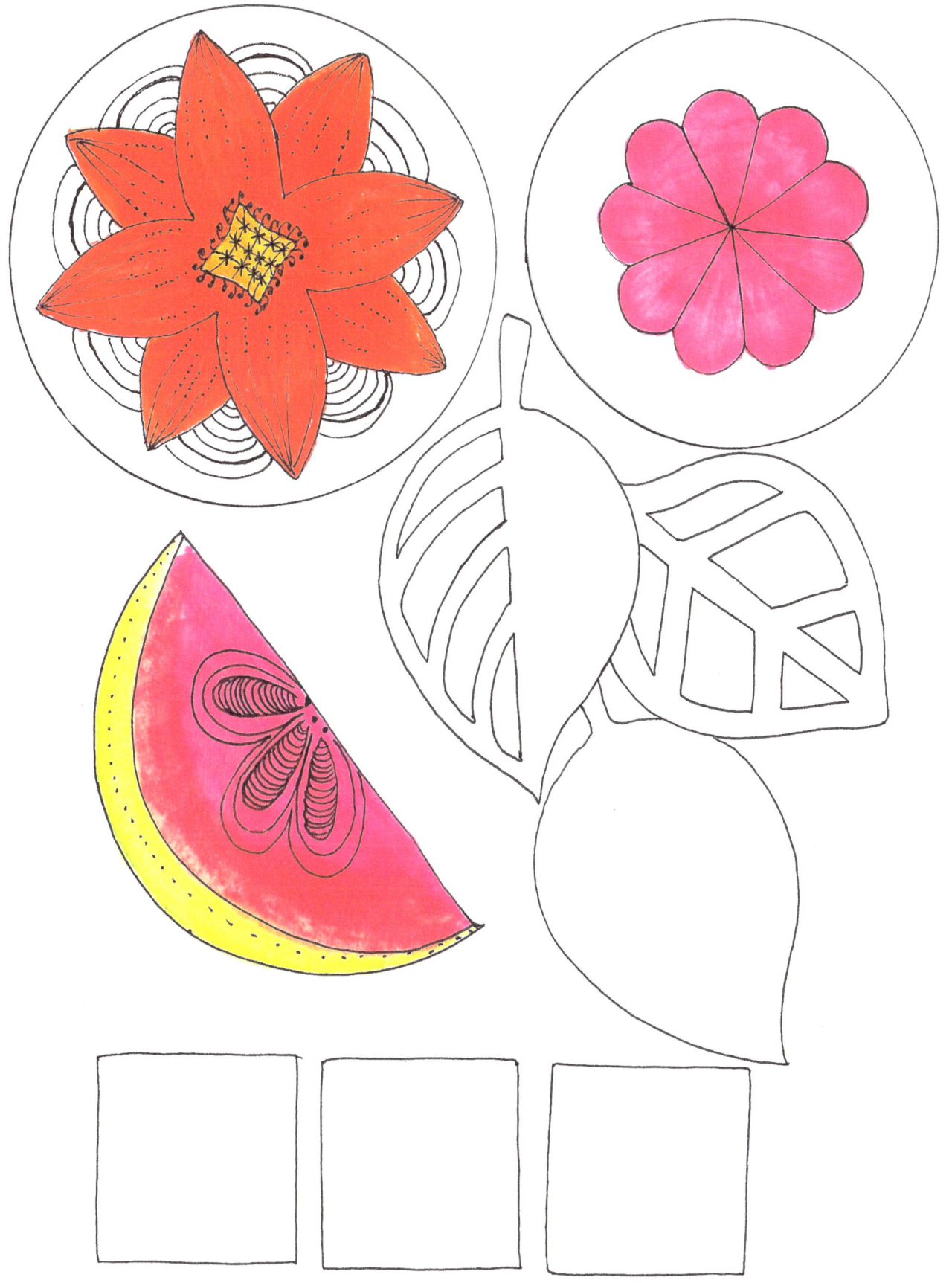

Bored with what's on TV? Tangle and let the TV be your background noise. Music is even better!

Are you hosting a sleep-over for children and their friends? To help them wind down so you can get some sleep, encourage them to tangle.

Tangle These

Getting together with some of *your* friends for coffee, dinner, or just to chat? Introduce them to Zentangle. It can become a ritual. Some friends and I get together on a regular basis to tangle. Sometimes we meet at Starbucks and sometimes at Panera. We even meet at the library where it's nice and quiet. Wherever you go, take a tangling kit with you. When being stuck in traffic or waiting at the Drs office, I tangle while I wait.

Here are some thoughts for you to consider...

Laughter invigorates me, while tangling revitalizes me.
I endeavor to tangle daily, even for a short time.

Be well and healthy, strong, whole, and mindful. Tangle daily for inner peace and greater focus.

It takes both rain and sunshine to make a rainbow, it takes only time to tangle to make life healthier.

Each day can bring new discoveries, new adventures, and new tangles into our lives. Embrace them all!

Be well and stay healthy, strong, whole, and mindful. Tangle for inner peace and greater focus. It takes no experience, just moments of time well spent.

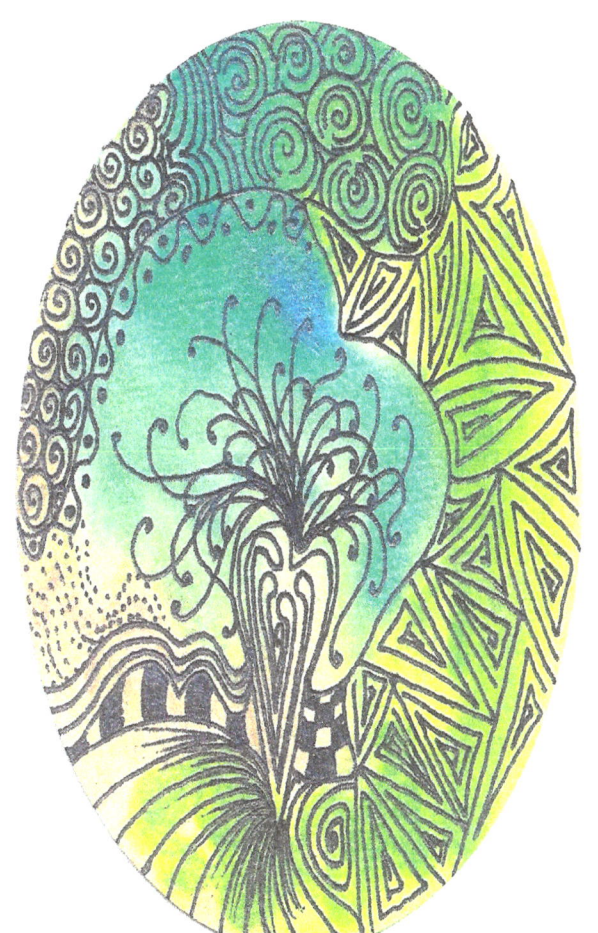

Gift a tangle to a friend.
They'll be thankful for it!!

Zentangle is an attitude of mind and heart that allows us to free our soul and renew our inner spirit

It has been a pleasure to create this book for you. My hope is that you'll enjoy it as much as I have enjoyed working on it.

While tangling won't solve life's problems, it does allow us to view life with a better attitude, lessen feelings of defeat, and most of all, Zentangle® offers us a chance to increase our sense of well-being.

I thank Rick Roberts and Maria Thomas for sharing this wonderful and mindful, art form with me and so many others. Zentangle® has dramatically changed my life, my perceptions, and it has increased my joy in sharing my creativity with others. May you find joy in the art of Zentangle®.

My best to you, *Jeanne* ♥♥♥

www.ingramcontent.com/pod-product-compliance
Lightning Source LLC
Chambersburg PA
CBHW050406180526
45159CB00005B/2164